200% Cotton
New T-Shirt Graphics

First published in the
United Kingdom in 2004 by
Laurence King Publishing
71 Great Russell Street
London WC1B 3BP
Tel: +44 020 7430 8850
Fax: +44 020 7430 8880
email: enquiries@laurenceking.co.uk
www.laurenceking.co.uk

First published in the United States by:
Harper Design International
an imprint of HarperCollins *Publishers*
10 East 53rd Street
New York, NY 10022
Fax: +212 207 7654

HarperCollins books may
be purchased for educational,
business, or sales promotional use.
For information, please write:
Special Markets Department
HarperCollins *Publishers* Inc.,
10 East 53rd Street, New York,
NY 10022.

Copyright © 2004
Laurence King Publishing

Library of Congress Control
Number: 2004106732

A catalogue record for this book is
available from the British Library.

ISBN 1 85669 400 3

Words: Helen Walters

Book design and cover illustration:
FL@33
www.flat33.com

Senior editor: Cleia Smith
Assistant editor: Stella Killery

Printed in China
First printing 2004

200% Cotton
New T-Shirt Graphics

Words: Helen Walters

Book design and cover illustration: FL@33

Laurence King Publishing in association with Harper Design International

an imprint of HarperCollins *Publishers*

INTRO

4

5

6

The power of the T-shirt graphic was brought home to me recently by a rather unlikely source: Richard Madeley and Judy Finnegan. To those for whom these names don't mean much, Richard and Judy (most commonly known by their first names) are the doyens of prime-time television in the UK. For years they oversaw British mornings; delighting housewives, distracting students and providing the material for many an obscure media-studies dissertation, with their five-minute discussions of topics ranging from erectile dysfunction to how to make the fluffiest sponge cake. A husband-and-wife team, they later went on to present an 'edgier' evening show on Channel 4, a channel with a younger demographic.

Who knows quite how, but T-shirt graphics came to Richard and Judy's attention. They decided to feature a segment showing some of their staff modelling their own favourite shirts. An 'expert panel' was invited to dissect the choices and analyse the psychology behind the clothing decisions. Which is why I, deemed an expert because of this book's precursor, along with a comedian and a former magazine editor, found myself on live national television, primed and ready to dispense wisdom on the sartorial choices of a group of complete strangers.

So far so surreal, but there were two moments of particular interest. Firstly, Judy picked up a T-shirt bearing the statement 'I Am Spartacus' from a pile on the table in front of her. Looking mystified and a little appalled, she declared that she would consider anyone wearing it an idiot. Then, the woman/expert next to me denounced the girl wearing a T-shirt bearing the logo of the British chemist *Boots* which had been amended to read *Boobs*.

'I think most people would be massively put off by that,' she said cheerfully. 'You've got a sweet little face but if you walked in with even a slight arrogance people would instantly dislike you.' Of course it's the nature of television to inspire forceful opinions, but it's also testament to the power of the graphics themselves that both women were happy to make such snap judgements about the personalities of the people wearing the clothes.

To a certain extent, of course, we all judge on appearance. T-shirt graphics provide a quick and easy way to do exactly that, giving a silent but powerful insight into the psyche and beliefs of whoever is wearing the shirt. For some reason, people feel absolutely entitled to comment on what's on the front of your shirt, regardless of whether you've ever actually been introduced. As such, what you wear genuinely affects your life (that day). Need cheering up? Wear something with a cute icon on it and more than likely someone will compliment you. Feeling provocative? Wear something emblazoned with a swear word and you'll undoubtedly outrage someone before too long. But the real beauty of T-shirts is that if you get sick of a certain reaction, if you change your mind about a graphic or the sentiment of a statement, you can simply stop wearing the shirt. They are like the training ground for that rather more permanent graphic statement, the tattoo. And while they are becoming increasingly expensive, T-shirts are still just about cheap enough to discard fairly easily so they can be the one-minute wonder in your wardrobe. Easy come, easy go.

Not that people do throw out their T-shirts, of course. In fact, they somehow stay in the wardrobe for years on end, long after other items of clothing are discarded for being out of season, style or favour. Such is the recyclable nature of fashion that what you might perceive as this month's fashion mistake is almost certain to become next month's retro trend.

Many companies continue to produce and sell – in enormous quantities – T-shirts simply emblazoned with their own logo. Even high fashion labels, notoriously sniffy about the low-grade, democratic nature of the T-shirt, have been known to deign to print their graphic identity onto a T-shirt, and then charge a fortune for it. But these are not the kinds of designs you will find featured here.

On the contrary, this book seeks to celebrate those designers or brands who are using the T-shirt as a canvas for genuinely innova-tive artwork. Young people, still the largest consumers of cool T-shirts, are keenly aware of their powerful role as mobile man-nequins advertising a brand or a product. As such, they require their brands to work hard for their money. The most sought-after T-shirt brands tend to be the ones that aren't mass marketed, the ones that bear references that only those people genuinely in the know will actually understand.

Take British artist JAKe's T-shirts for George Lucas's *Star Wars* films, featuring illustrations of lesser-known characters from both the original trilogy and the newer movies. Wearing a T-shirt adorned with the character of Boba Fett is more compelling for a real fan, who avoids having to talk about the shirt to someone who only vaguely remembers a bloke called Darth something. In many cases, certain icons have become a lazy shorthand for people wanting to tap into a trend or movement for reasons other than genuine interest. By wearing more obscure references to their passions, real fans stay one step ahead of followers trying to muscle in on the action. The more in touch you are (and therefore the cooler you are) if you get it. As artist and designer Scott King points out: 'A Kurt Cobain T-shirt does not a tortured rock star make.'

In these irony-saturated times it's also important to remember that what you see is not always what you get. The girl wearing the *Boobs* T-shirt on *Richard and Judy* was horrified at the idea that someone might find her arrogant, insisting (quite reasonably) that she simply thought the graphic was a witty play on some very recognizable branding.

Some designers have started to explore this tension between who you are and what you wear. Legendary, maverick graffiti artist Banksy recently produced a shirt which simply read 'Tagger Scum', a recognition (and celebration) of the traditional vilification of graffiti by more conservative parts of the media. By wearing this type of T-shirt, those with a genuine passion stay one step ahead of those just along for the ride. New York based designer Ryan McGinness printed a T-shirt with the phrase 'Graphic T-shirts are Lame', which is now sold in boutiques selling the most

most cutting-edge clothes and, ironically, graphic T-shirts. All in all, it's a convoluted, twisted game with no fixed rules, and brands have to be sharp to keep up. Some of them, of course, tap into an existing part of the subculture to garner cool points by association: Levi's commissioning the likes of street artist Shepard Fairey, or Kim Jones designing for Umbro are cases in point.

Music has always been the traditional exploiter of the T-shirt, with bands still offering them up alongside their albums as a typical gig souvenir. However, just as some brands have accepted that they have to work a bit harder for their consumers' money, so too have many bands realized that they can't simply reproduce their album-cover graphic on the front of a shirt and stick their tour dates on its back. Again, fans are interested in subtler, more oblique references, so many bands don't even bother to feature their own names in their imagery any more.

Scott King recently produced a series of T-shirts for the UK pop act, Pet Shop Boys. 'I wanted to get away from the worthy but lazy idea of printing the CD sleeve (badly) onto a T-shirt', he says of the collection. 'I was aware of how much Mark Farrow had been associated with Pet Shop Boys' graphics, and vice versa, so it was obvious I couldn't go down the "stylish, minimal" route for anything I did for them, as they may as well have got him to do it (much better).' So King came up with a series of phrases which were then printed onto the front of the shirts. Not specifically referring to the group (apart from one, which used their lyric 'Being Boring'), phrases included 'Sexy Northerner', 'Quite Heavy Metal' and 'Blackpool Rock & Roll'. Without having to labour the point, the tone is pure Pet Shop Boys. 'Having a T-shirt saying "Closet

"Closet Homosexual" for a fan to buy at a gig seemed good fun whether the fan was gay or straight', says King.

Then, of course, there are the designers and illustrators creating T-shirts purely for themselves and anyone who might be interested in their work. In recent years, more and more of these creatives have realized that by printing their own T-shirts they can reach a whole new audience with their work. Using the shirt as a cheap canvas, they can also try out ideas which they (for whatever reason) haven't been able to sell into the commercial world. With the ubiquity of the internet and people's increasing willingness to buy items online, designers can sell their work directly to a potentially massive audience.

San Francisco-based illustrator Michael Gillette founded the company Rinky Dink while living in the UK. 'I did it because I had a load of ideas for Ts which were nothing to do with the work I was known for, so nobody would have come looking for me to do them', he says. 'They were things I wanted to see made so I put up some money and got them done. Subsequently, people know I do Ts and I've been commissioned to design them too. It's snowballed from there.'

'I think of T-shirts as a pop-culture laboratory,' he continues. 'They are a repository for all the flip, dumb and more graphic ideas I have which don't fit into my work elsewhere. My other work is all about nuance, texture and attention to detail. My mandate for a T-shirt is that it should work in one color. It should be that simple. I'm not precious about them, they are good fun so I try not to dampen that spirit by thinking too much. I just have random ideas that pop up and I think, Hmm … that would be cool.'

In recent years designers have also begun to use interesting or unexpected materials to create a more special and desirable item of clothing. British company Danger produces shirts with its trademark monsters cut out of felt and hand-stitched onto high-quality cotton. The placement of graphics has also become a factor, with designers regularly printing onto the sleeves and sides of shirts as well as the traditional front and back area. New York duo Doug & Johnny printed the outline of the state of Texas onto the front of one of their shirts, with the word Iraq in Arabic script to one side. Helicopter gunships fly over the wearer's shoulder, looking from a distance, says the label's Johnny Vulkan cheerfully, 'just like blood spots'.

Perhaps not surprisingly, given the current global state of unrest, polemic seems to be coming back into style. Organizations, charities and political causes have traditionally kitted out their followers in a specially printed T-shirt to promote a certain way of thinking, but individual designers are now regularly using the T-shirt to promote less specific causes or beliefs. Welsh company howies produces T-shirts which address environmental and global political issues in uncompromising terms. Along with their thought-provoking images related to the recent Gulf War, Doug & Johnny have also commented on the notoriously powerful American gun and pharmaceutical industries.

'The T-shirt business has exploded, but so much stuff is just average,' says Vulkan. 'We want to do something with intellect behind it rather than come up with just another cool graphic. Of course, some people do just like our shirts for their graphic icons, but we want to reward our consumers on a deeper level too. Above all else we don't want to preach at people, we want to start a debate. We do have our own opinions which come through in our designs, but if you disagree with us that's absolutely fine, great in fact.'

'The T-shirt is simply an updated version of the Victorian sandwich board,' says Pentagram partner Woody Pirtle. 'It can be an extremely useful tool for social statement.' As war broke out with Iraq in 2003, Pirtle co-opted his company's graphic identity to make his own political statement, changing the flag that hangs outside their New York office to read 'Peace' instead of 'Pentagram'. 'After we did the flag, the next obvious step was to make some T-shirts too', he explains. 'We put "Peace" on the front, the Pentagram logo on the sleeve and gave them away to people. Not only was it an identifier for us as a company, but it was linked to our stance on the war.'

It's almost hard to believe that the humble T-shirt can inspire so much thought and analysis, but it's certainly heartening to see that so many young artists are seizing the opportunities afforded by the medium. This book features work by a disparate group of fiercely independent and uncompromising designers, and presents an inspiring snapshot of the current state of global creativity. Even after all these years, the T-shirt – it seems – remains in pretty good shape.

Helen Walters

BUY

14

BUY

More and more, designers are doing it for themselves, using the T-shirt as a canvas for ideas they can't use elsewhere. This chapter celebrates designers who have branched out to start their own T-shirt-based sidelines.

15

BUY

Stacks
Rasa Libre

www.commonwealthstacks.com
www.rasalibre.com

San Francisco-based designer
Michael Leon began printing T-shirts
under the name Commonwealth
Stacks Conversation Editions in
January 2000. In 2002, he began to
collaborate with his wife Laura on a
more formal, seasonal line, simply
called Stacks, while in 2003 he
started his own skateboard company,
Rasa Libre. Graphic-based T-shirts,
of course, form a prominent part of
both labels.

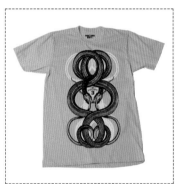

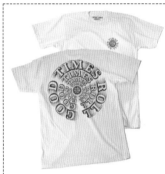

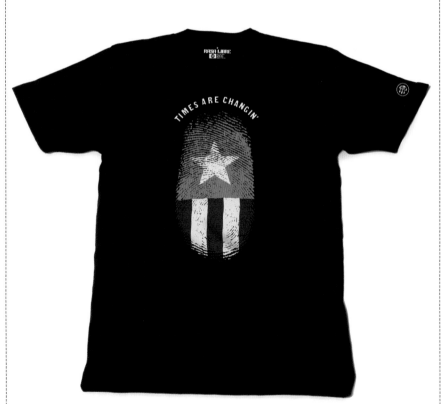

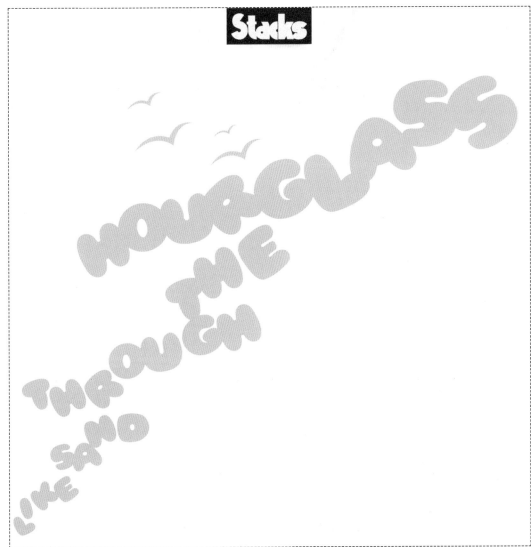

BUY

Lemon Twist
www.lemontwist.net

'We design for people who know how to put things together in a clever sort of way', says Danette Scheib of San Francisco-based clothing label, Lemon Twist. Scheib started the line with her husband, Eric, back in 1999 and together the pair indulge their love of retro graphics, including 1950s' Public Service Addresses from Romania and Asian advertising from the 1920s.

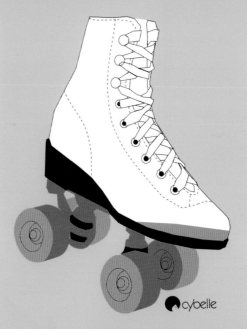

Cybelle

www.cybellegear.com

Emily Goodwin and Gabriella Davi-Khorasanee set up Cybelle in 2001 as a 'streetwear company created by ladies for ladies'. With Goodwin based in Philadelphia and Davi-Khorasanee in San Francisco, the pair meet up about four times a year to brainstorm design concepts for their next season. The design work happens on their respective sides of the country, with Illustrator files sent back and forth via email.

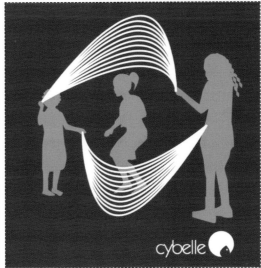

19

alife

www.alifenyc.com

More than just another fashionable store, alife is, well, a way of life. Founded by Tony 'Site' Arcabascio, Tammy Brainard, Rob 'Jest' Cristofaro and Arnaud Delecolle in 1999, alife's space on New York's Lower East Side features all the rare and limited-edition clothes, trainers, toys and accessories that a contemporary culture junkie could ask for. Their own labels of clothing and footwear reflect both their attitude and aesthetic: bold but beautiful. *Design: Tony Arcabascio, Rob Cristofaro and Arnaud Delecolle.*

Alife Rivington Club

ALIFE
CONSTRUCTION
178 Orchard Street
New York City, N.Y. 10002
(646)654-0630

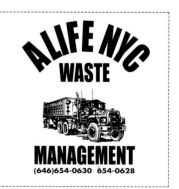

howies
www.howies.co.uk

David and Clare Hieatt originally started howies in 1995, printing T-shirts at home and travelling all over the UK to sell them out of the back of their car. 'Our mission as a company is try to make people think about this brilliant world of ours,' they explain proudly. 'We do that with our own sense of quirky humour.' Though they now produce accessories and other clothes, T-shirts remain a focal part of every collection. *Design: Brandwashed: Ross Cooper. Enron, Peace B52 and George Bush: Pete Davies. Fish Farms Fuck Fish: Richard Beards. Life: Daisy Cresswell. GB Ltd: Neil Craddock.*

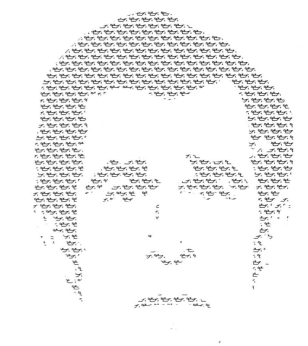

6876

www.sixeightsevensix.com

London-based clothing label 6876 has been attempting to sneak provocative and thought-provoking imagery into the fashion world since its inception in 1995. As founder Kenneth Mackenzie puts it, their aim is 'to produce innovative clothing and evolve as a product/ideas brand while steadfastly adhering to independent, non-corporate values.' *Design: Kenneth Mackenzie. Graphic arrangement: Mike Lawrence, 1999–2002.*

i'm SO outer SPACE

Menu Design
www.neuty.com/menupage.html

Mark Kane and Doris Ho started
Menu Design in August 2002 to
create T-shirts, bags and patches.
Currently producing everything from
their studio apartment in New York,
their designs and illustrations are
light-hearted and really rather sweet.
Their long-term plan is to open a
store with a vegan bakery onsite while
they also use T-shirts as a medium for
their vegetarian-friendly philosophy.

LE LAPIN HEUREUX
RABBIT SANCTUARY

Angry.

BUY

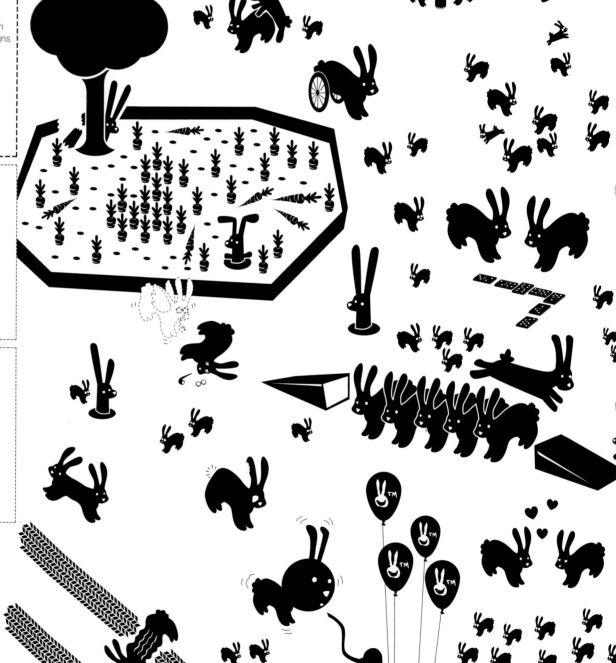

24

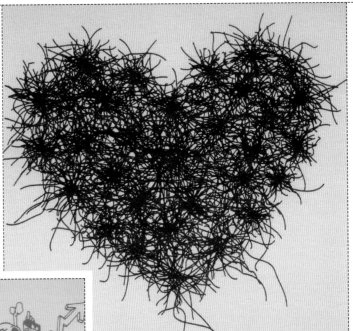

Da Hee Projects
www.daheeprojects.com

Susan Oak founded Da Hee Projects in 2003 and commissioned her peers to design T-shirt graphics inspired by anything they liked. The results were eclectic, to say the least. The shirts are currently only available to buy though Da Hee's website, although Oak hopes to open a store in San Francisco at some point in the future. *Design: Susan Oak, Riley Swift, David Nason, Jason Kuhlman, Joel Davis, Brad Tucker.*

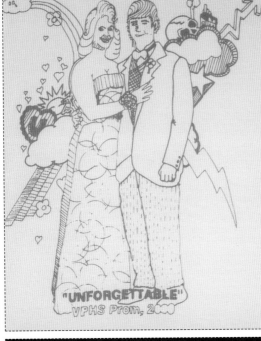

Doug & Johnny
www.dooker.com

'The T-shirt is a visible, human billboard,' says Johnny Vulkan, co-founder (with Doug Jaeger) of New York-based clothing label, Doug & Johnny. 'They're worn everywhere and so it's a medium to get information out on. We thought it would be neat to create iconography and a brand that's true to America.' Their designs include hard-hitting references to the country's gun culture as well as the United States' involvement in recent global political events. 'We create these shirts to raise a debate', says Jaeger.

BUY

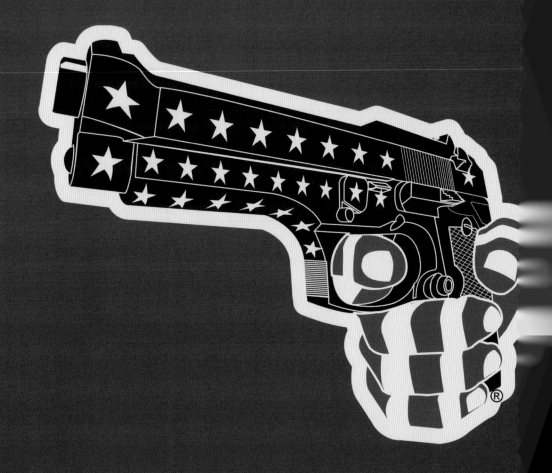

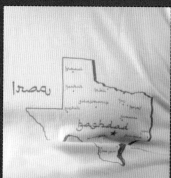

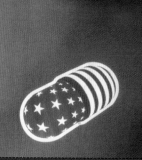

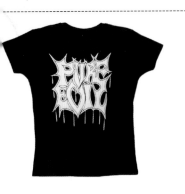
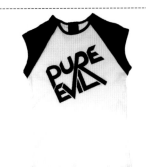

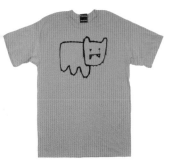
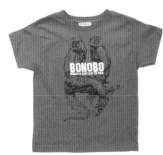
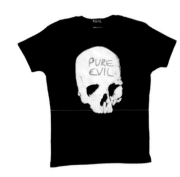
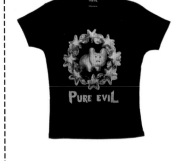

Pure Evil

www.pureevilclothing.com

Charles Uzzell Edwards used to live in California, where he worked as a designer for Anarchic Adjustment. Now based in London, he produces two lines for Pure Evil each year, with toys and artworks featuring alongside numerous T-shirts. The line is, apparently: 'for death-metal boys and for pop-gothic girls who like combat-rocker boys who like graffiti-art girls who like dark-side DJ boys who like eclectic-electronic girls who like knee-scuffed skateboarder boys who like to boldly go where no-one has gone before.' So that's that then.

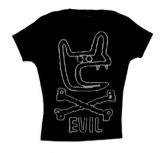

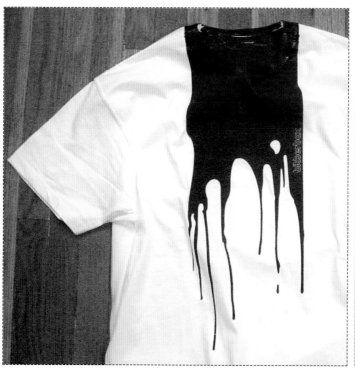

bibberbox

Designer Bobby Friese launched bibberbox in Chicago in 1999 as a way to combine his interests in fashion, fine art and graphic design. The images are printed onto organic cotton shirts using a variety of hand-applied techniques, while numbers of each edition never go above 500. Now based in New York, Friese uses childhood photos and everyday objects as his starting point, before deconstructing the images beyond all recognition.

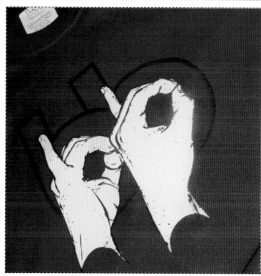

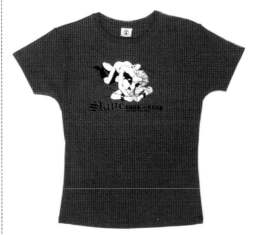

Terratag
www.terratag.com

Paul Nicholson launched Terratag in January 2003 to create a range of graphic products, including T-shirts, stickers, posters and canvases. Inspired by all things Japanese, Nicholson describes the look of the label as a Euro-Japanese hybrid. 'I love Japan, although it is a culture I can never fully comprehend,' he confesses. 'This lack of understanding is my fashion laboratory. Where an experiment is conducted. Where a mutant, cross-cultural hybrid is born.'

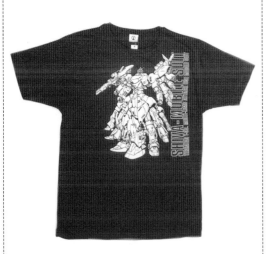

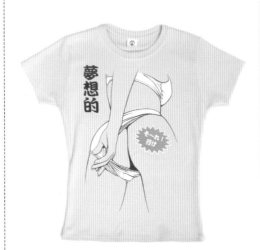

HandGun
(BuyProduct)

www.hand-gun.org

Having worked at companies such as adidas and Pony, David Zack Custer founded his own design agency, HandGun, where he happily works across all media, including print, web and motion graphics. Based in Portland, Oregon, Custer has produced T-shirts for clients such as DruknMunky and Fltr as well as his own line, HandGun (BuyProduct). 'I mostly experiment with images I come across and find subconscious messages hidden within', he says.

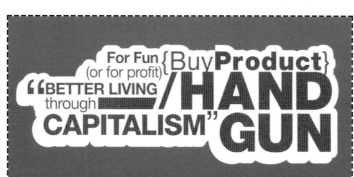

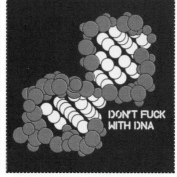

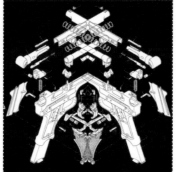

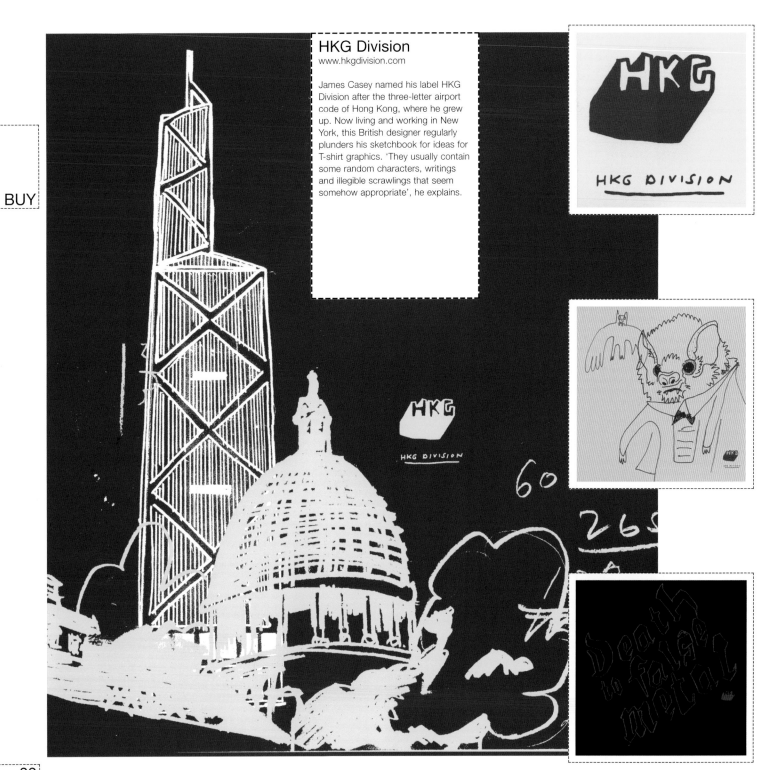

HKG Division
www.hkgdivision.com

James Casey named his label HKG Division after the three-letter airport code of Hong Kong, where he grew up. Now living and working in New York, this British designer regularly plunders his sketchbook for ideas for T-shirt graphics. 'They usually contain some random characters, writings and illegible scrawlings that seem somehow appropriate', he explains.

StolenShirts
www.stolenshirts.com

Thomas Brodahl started StolenShirts in Luxembourg in early 2002. 'The idea was to produce fashionable designs on high-quality shirts that were still very affordable', he explains. Featuring his trademark illustrations and designs, the shirts are available to buy online. Brodahl recently moved to live and work in Los Angeles.

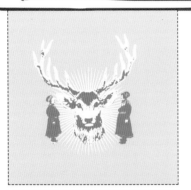

Stolen

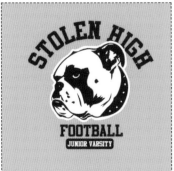

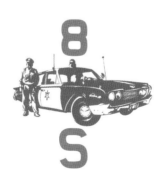

BUY

Call of the Wild
www.ofthewild.com

Kai Clements and Sunny started Call of the Wild as a 'homage to nature and the disturbed environment'. The label is an offshoot from their already-flourishing graphic design business: the pair have worked for clients such as Mo Wax, Maharishi and CND. 'The main reason we like designing clothes is that people actually buy our prints to wear, which means they must like them', explains Kai. 'People generally buy records for the music and not the sleeve design, so it makes us very happy when we see somebody wearing a garment of ours.'

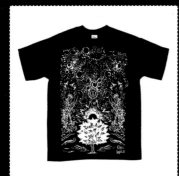

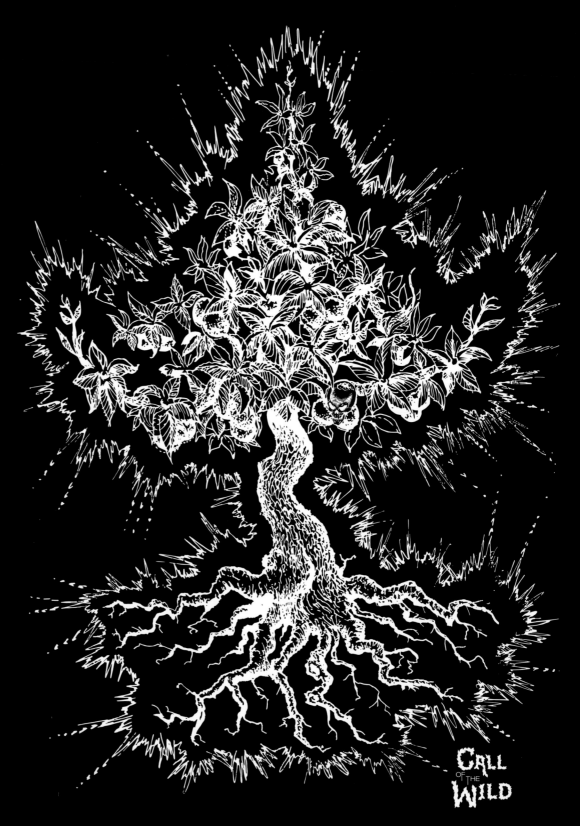

Lost & Found

www.lostandfoundnyc.com

Chris McNally and Melanie Samarasinghe founded the label Lost & Found in New York City in March 2003. Featuring joyfully retro imagery, their T-shirts are screen printed or airbrushed by hand, while all pieces are produced in very limited editions. 'Everything is based on nostalgic images from past times and locations,' explains McNally. 'Our first line was inspired by cotton candy, the sparkle of metal-flake paint, and long waits for cheap thrills.'

Uniform
www.form.uk.com

Originally an offshoot of London-based graphic design company Form, Uniform is now a fully-fledged clothing label, stocked by over forty shops in the UK and Europe. 'The brand is bold, graphic, contemporary but not faddish, stylish and original, iconic, witty and well designed and confident', says Uniform's co-founder Paula Benson. 'We take cultural references and play with them out of context'. *Art direction by Paul West/Paula Benson. Design by the Form/Uniform team.*

Rachel Cattle
www.rachelcattle.co.uk

London-based designer Rachel Cattle started to print T-shirts after realizing that many of her illustrations featured female characters. 'Some were of me, some were girls in my family and often they included elements from stories and imaginary creatures that I remembered,' she explains. 'I liked the idea of people wearing the girl drawings and so I started producing T-shirts. It gives them a new dimension and the drawings really change depending on who is wearing them. I love that.' *Design: Rachel Cattle. Photography: Steve Richards.*

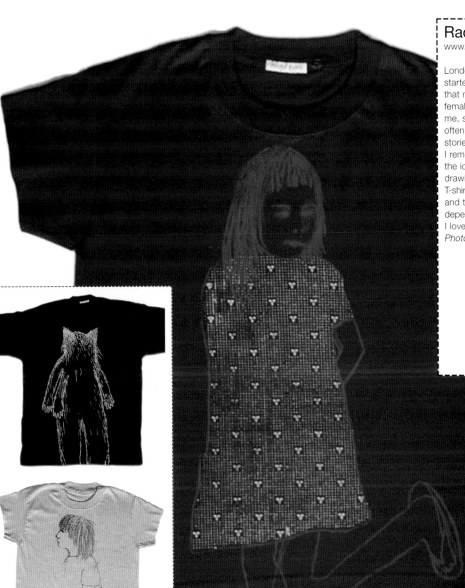

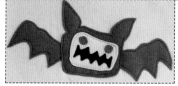

Danger
www.danger.uk.com

British illustrator and designer Ange Hayward began sewing monsters onto clothes as a hobby, but before she knew where she was, demand was getting out of control. 'I decided to stitch more often and that's how Danger was born', she explains. She describes the monsters as: 'scarily cute, and fluffily crazy. Danger characters are daft and friendly but with a bit of a nasty cackle too.'

BUY

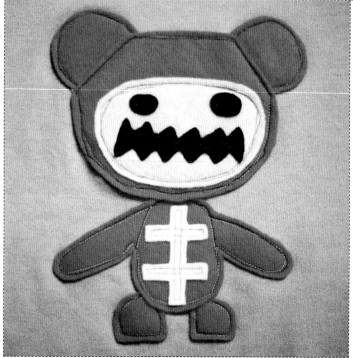

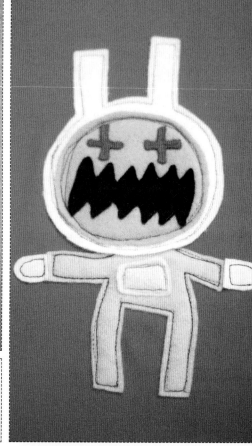

 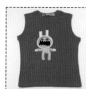

WARNING! KEEP AWAY

LIKE SHOUTING

danger! stay back

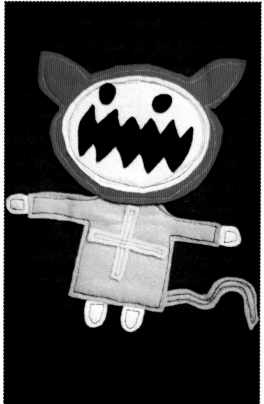

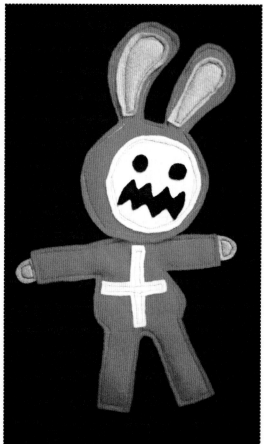

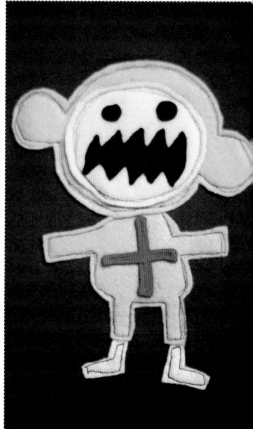

10.Deep
www.tenthdivision.com

'The graphics I design are often a reaction against other T-shirts I see around, based on current music, political and fashion trends', says Scott Sasso of Brooklyn-based label 10.Deep. 'The thing that I take the most time on is finding a new or interesting way to convey an old or simple idea. A T-shirt that reveals itself too easily or too quickly is not interesting.' We particularly like the 'Unsigned/Unnumbered' shirt which good-naturedly mocks the pretensions of limited-edition T-shirts everywhere.

UNSIGNED
UNNUMBERED
1/∞

SEARCHING

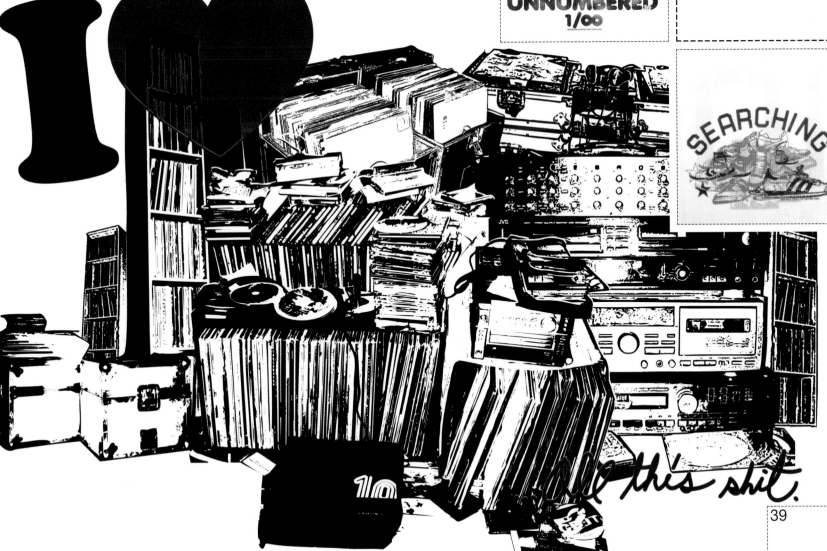

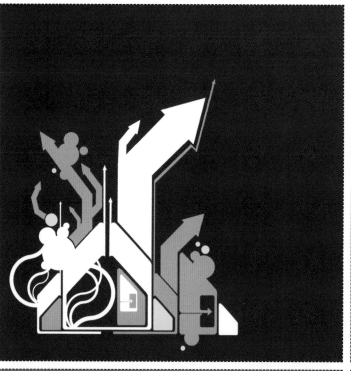

Mitch

London-based artist and designer, Mitch, deliberately maintains a varied existence, working for commercial clients including the Wall of Sound record label, *Straight No Chaser* magazine and Addict clothing, showing personal prints and artwork in exhibitions around the world and also touring as the flautist for music act, Kinobe. Of designing T-shirts, he says simply: 'It's different from designing anything else. With T-shirts, the design is all there is. Its sole purpose is aesthetic, so the buyer is making a choice based on the design's communication only.'

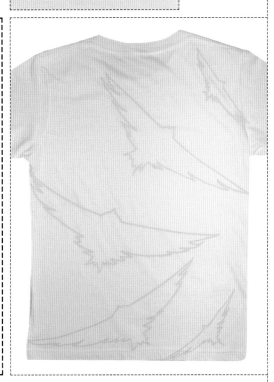

Duel Industries
www.duelindustries.com

Duel Industries is the brainchild of Brooklyn-based designer, Eden Marland, who delights in attaching philosophical ideas to design. 'The Freebird T represents freedom of speech, with the alphabet showing individual control over words and the soaring bird relating to the experience of freedom', Marland explains. Duel produces an official T-shirt each year, with the 2003 shirt showing a series of rather angry-looking scars. 'But the wearer has survived', Marland reassures us happily.

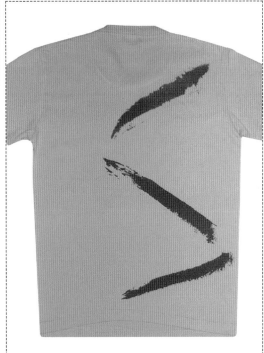

Five Four Clothing

www.fivefourclothing.com

Andres Izquieta and Dee Murthy founded Five Four Clothing in Los Angeles in 2002. 'The name came from an urban slang that equates the term "Five Four" with "one" or "one love"', says Izquieta. 'Five minus four equals one, and thus Five Four Clothing was born.' Inspired by 'culture, youth, hip-hop music and LA', the pair often collaborate with designers Michael Asis Herrera and Jonathan Dahan and describe their style as 'a combination of abstract and vector'. (Thankfully you don't have to be good at maths to appreciate the graphics.)

BUY

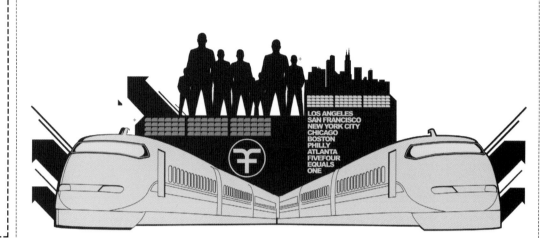

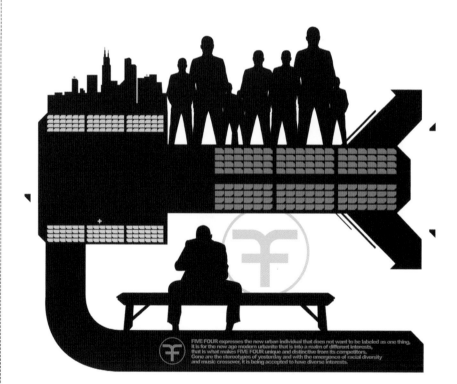

Neenoon

www.typevsm.com

Los Angeles-based designers Ben and Reneé Loiz started Neenoon in 2002 as an offshoot of their design agency, Typevsm. Selling T-shirts, pillows, sweatshirts and bags, their graphics are often type-based while their philosophy is to create items that are 'fun, thoughtful and nice to look at'.

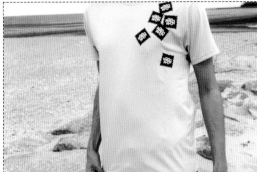

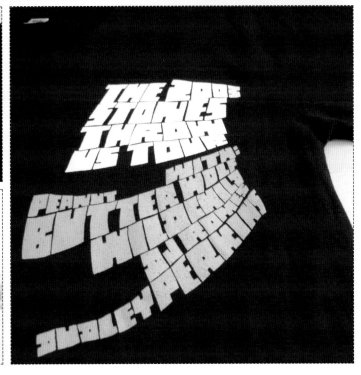

By The Factory Wall
www.ByTheFactoryWall.com

Clothing label By The Factory Wall evolved from a series of slogan-based T-shirts produced by Cuan Hanly and Jonathan Parson, and sold in Hanly's store in Dublin in 2000. Now working in west Cork in Ireland, Hanly and Parson describe their graphics and clothes as: 'informed by the "Irishness" factor. A little humorous, a little irreverent and certainly unique. There is a little Irish in everyone!'

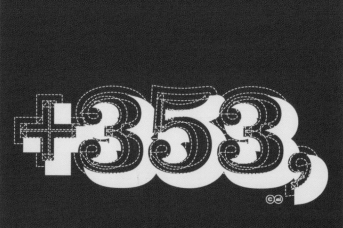

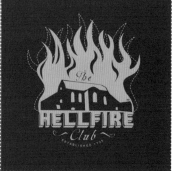

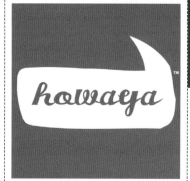

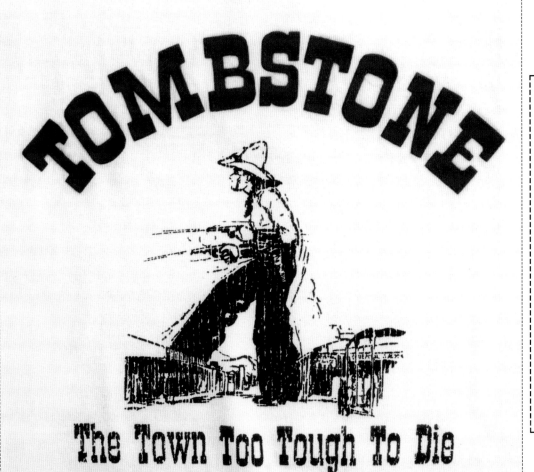

Left Field
www.leftfieldnyc.com

Having always been into thrift-store shopping, Christian and Lara McCann decided to start their own clothing line to prove that 'it doesn't have to be vintage to be well made'. Initially taking inspiration from 1950s' varsity sportswear, their T-shirts come complete with hand-stitched chenille or felt lettering. Later collections have seen the McCanns move on to take inspiration from other aspects of American society, including 'white trash, bikers, gangsters and criminals on the run'.

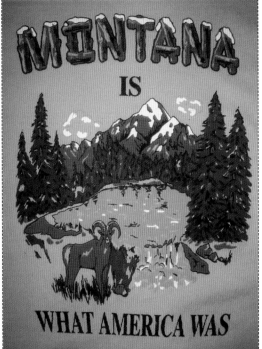

45

BUY

Green Lady
www.greenlady.com

Designers Todd St John and Gary Benzel founded independent clothing label Green Lady in San Diego, California in 1995. 'We try to make designs based on things that we find funny or ironic, or that we're interested in at the time,' says St John. 'Generally each year there's also some sort of conceptual thread that runs through everything.' *Design: Green Lady. Plane: 2000. Devil, Rabbit: 2001.*

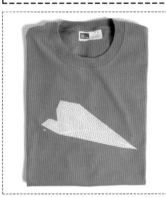

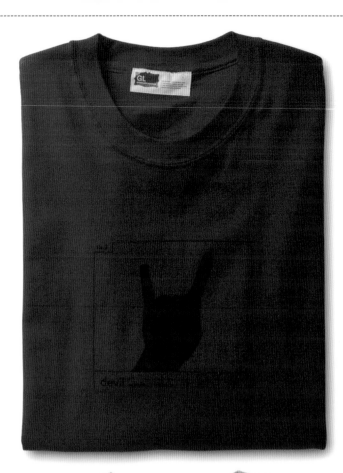

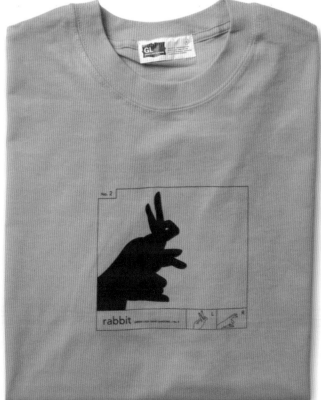

Hospital Radio

www.hospital-radio.com

Hospital Radio is the brainchild of designer William Cossey from Protoype 21. The look of the label comes from a nostalgia for a time 'when hospital radio DJs were cool and everyone had a Rubix Cube', he explains. 'We are influenced by music from The Beastie Boys and Nirvana to Michael Jackson and In Deep. Also watching *Back to the Future*, *The Time Bandits* and *Knight Rider*.'

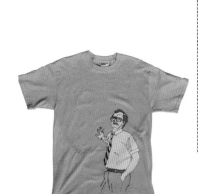

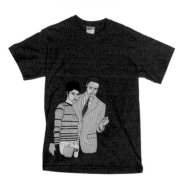

47

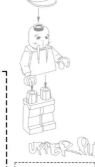

Upper Playground
www.upperplayground.com

'Upper Playground represents the essence of American city culture', says a proud Denis Kennedy, who designs for the San Francisco-based line alongside Matt Revelli, Adam Krohn and Matt Yep. Inspiration for their graphics come from such sources as hip-hop music, sports, pop culture and skateboarding. 'A street lamp against the evening sky or the beautiful chaos of an overhead freeway interchange seems more interesting than a brand name on the front of a shirt,' Kennedy continues. 'People want intelligent and thought-provoking images.'

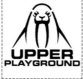

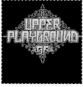

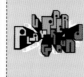
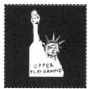
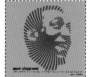

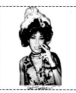

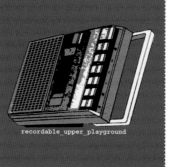

3

141592653589793238462643383279502884197169399375105820974944592307816406286208998628034825342117067982148086513282306647093844609550582231725359408128481117450284102701938521105559644622948954930381964428810975665933446128475648233786783165271201909145648566923460348610454326648213393607260249141273724587006606315588174881520920962829254091715364367892590360011330530548820466521384146951941511609433057270365759591953092186117381932611793105118548074462379
Harco & Metro
www.harcolate.com

Harco is actually the pseudonym for Japanese musician, Aoki, while Metro is the alter ego of designer Naoyuki Kurata. Having first collaborated on a merchandising project which proved hugely successful, the pair continue to design and produce T-shirts. 'The inspiration for designing those shirts still comes after hearing Harco's songs', says a happy Metro.

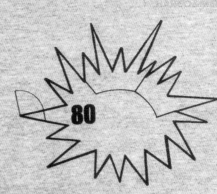

space estate 732

80

palace gizagiza ,5-32-11,dockiri-cho, odoro- ku,tokyo

Subsurface

www.subsurfaceuk.com

'Subsurface evolved out of an eclectic array of influences including Kung-Fu and classic icons, incorporating a uniquely British sense of humour with international urban culture references', explains David Walker who started the Southend-on-Sea-based label with Keith Watts in 2001. 'It was born out of the desire to have our own creative platform from which we could express ourselves freely through art and design.' *Design: David Walker, Keith Watts, Patrick Wagstaff.*

BUY

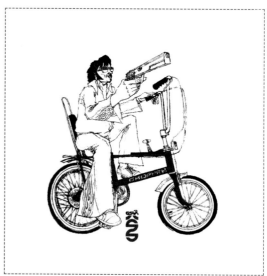

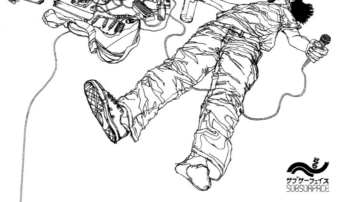

Imperfectionist

www.imperfectionist.co.uk

'T-shirts are a convenient and public canvas for graphic ideas,' says Matt Utber, founder of London-based label, Imperfectionist. 'They are also a way of avoiding difficult clients', he adds happily. Having said that, they're also a catalyst for clients interested in harnessing Utber's design and illustration skills: since its inception in 2002, Imperfectionist has worked on projects for the likes of MTV and chef Jamie Oliver.

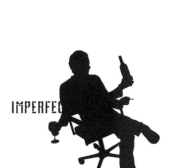

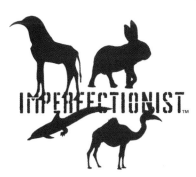

Michael Gillette
www.michaelgillette.com

Illustrator Michael Gillette produces simple but eye-catching T-shirts featuring entertaining slogans and rather lovely line-drawn icons. He founded clothing label Rinky Dink while living in the UK, winding down the line when he left for San Francisco in 2001. However, he continues to use the T-shirt as a canvas for his more left-field ideas, now selling them directly through his own website.

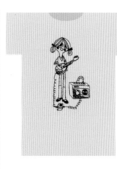

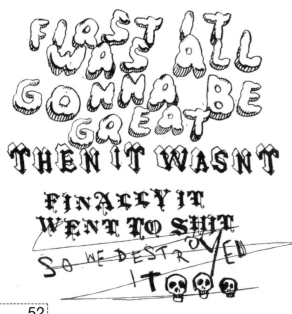

SHOOT

54

SHOOT

Young, old, fat, thin ... the T-shirt is one piece of clothing that is worn by everyone, everywhere. We should know, we photographed T-shirt clad passers-by in the following cities: Cardiff, Frankfurt, London, New York, Paris, Sydney and Tokyo.

Photographs
were taken in, by:

Cardiff: Peter Mace
Frankfurt: Helen Walters
London: Allison Wightman
New York: Leigh Ann Boutwell
Paris: Achim Reichert
Sydney: Paul McNeil
Tokyo: Steve Lidbury and yy
(with thanks to Ayako Terashima)

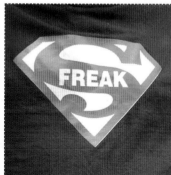

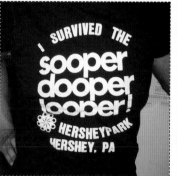

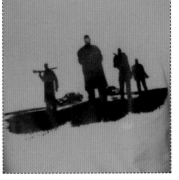

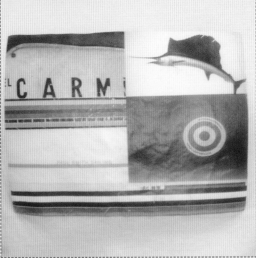

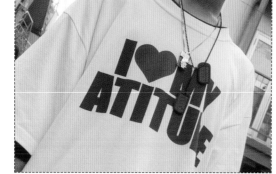

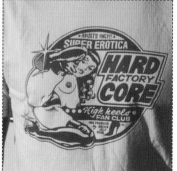

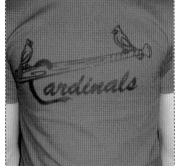

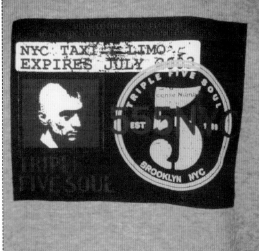

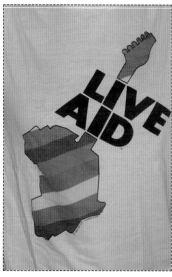

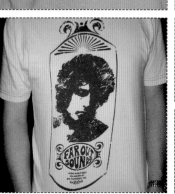

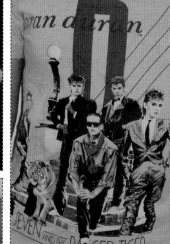
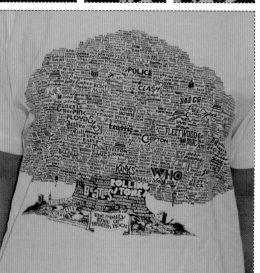

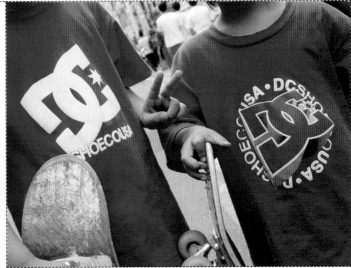

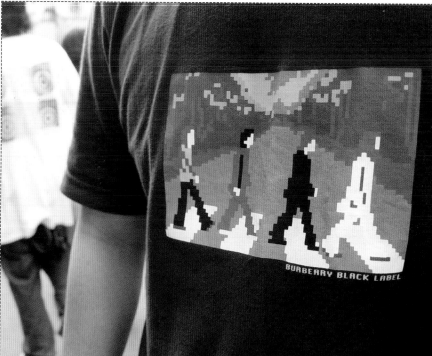

BURBERRY BLACK LABEL

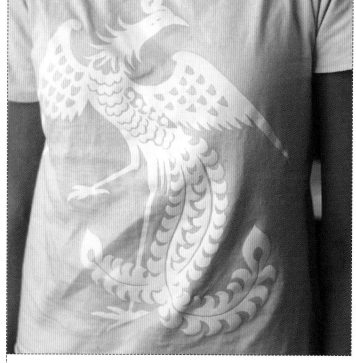

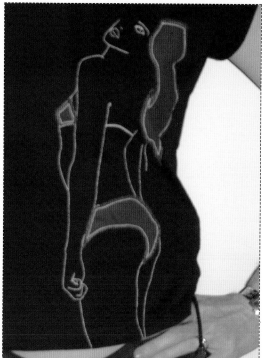

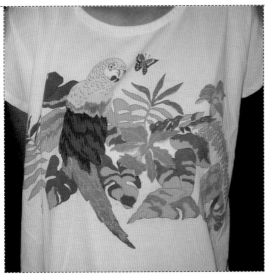

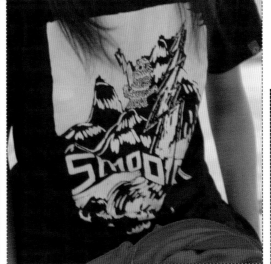

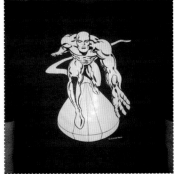

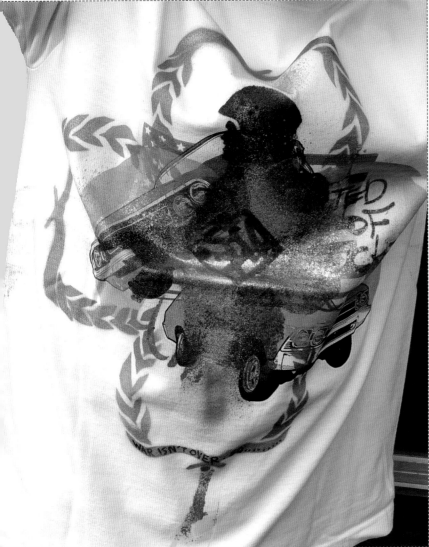

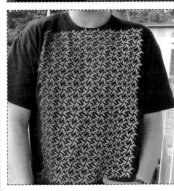

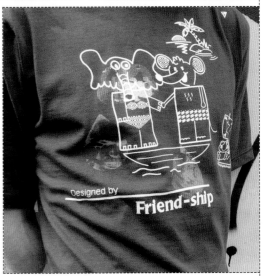

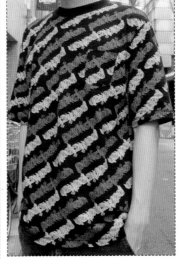

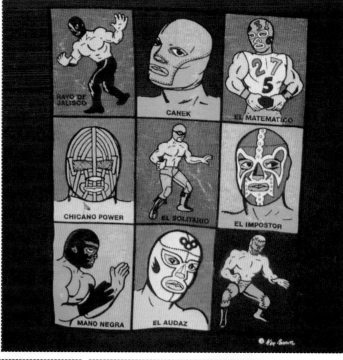

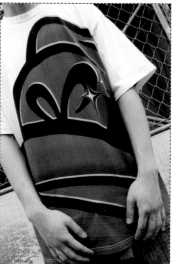

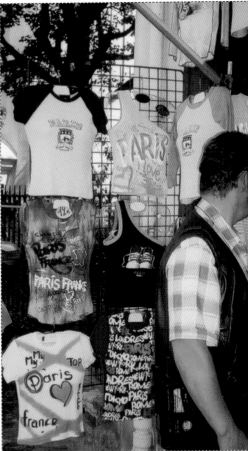

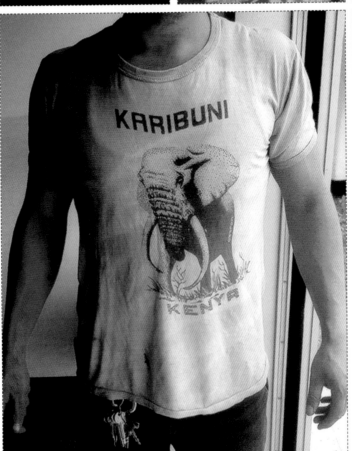

200%

66

200%

'200%' we said, and then ran away and left these various designers to design a related T-shirt graphic. The results couldn't be more eclectic, from illustrative to typographic to downright bizarre, while in some cases they're really not related to the brief at all. Nonetheless, this chapter presents a snapshot of some truly creative thinking from a wildly talented group of international artists and designers.

Deanne Cheuk

www.neomu.com
www.Liness.net

Australian-born, New York-based designer Deanne Cheuk has art directed and designed no less than thirteen magazines, including the hugely well-regarded *Tokion*. Not content with all that, she also produces and publishes her own magazine, *Neomu*. Featuring only images, with no text or advertising, the title has achieved cult status since its launch. Of her 200% design, Cheuk explains, 'I did this graphic at a moment when I was totally obsessed with eyes. That day I just drew them on everything and that also happened to be the day I did this design.' Yes, there are 200 of them.

200%

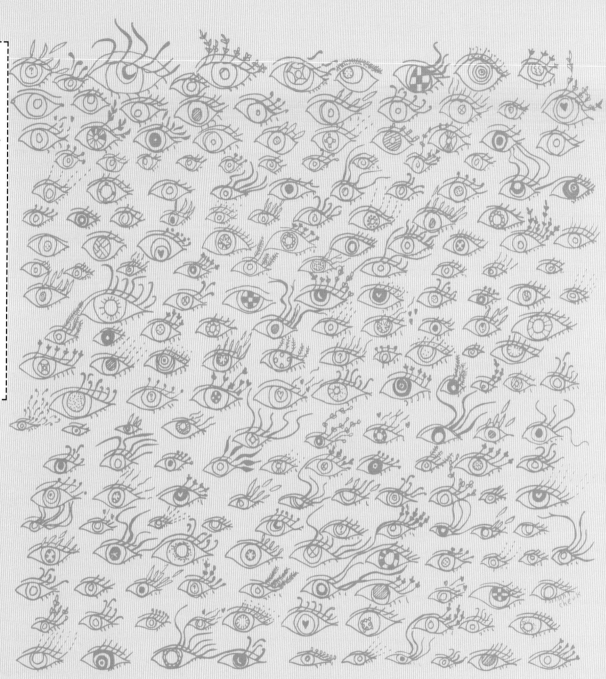

Mode 2
www.picturesonwalls.com

Something of a legend within the graffiti community, Mode 2 first began his spraycan-related experiments in the early 1980s, although as he explains, he's been interested in all forms of art since early childhood. 'I have always drawn, I grew up on comics and sci-fi fantasy literature,' he says. 'Then I got into hip-hop and I have been doing graffiti ever since.' As such, a silkscreen sprayed with a dripping 200% seemed a fitting solution to our brief.

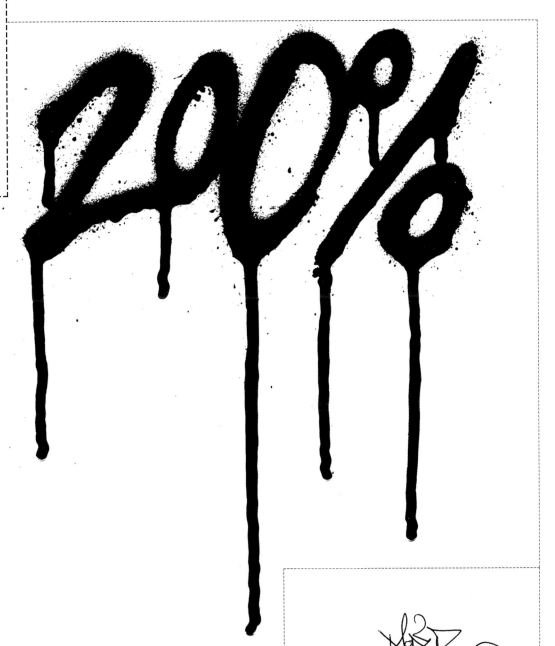

GH avisualagency™

www.ghava.com

GH avisualagency™ is actually five designers: four based in New York (David Merten, Derek Lerner, Randall Lane and Sadek Bazaraa), the fifth (Peter Rentz) living and working in Los Angeles. 'Our interests lie in the exploration of collaborative process, its effect on commercial design projects and on our fine art', explains Rentz, who initially worked on this design before passing it back to the New York office. 'Each member pursues his individual creative goals and then brings that experience to bear on the collaborative work done within the company.'

200%

Anthony Burrill
www.anthonyburrill.com

'It's a nod to my 4-pence-a-copy days,' says British designer Anthony Burrill of this design. He's referring to a time in the not-so-distant past when a trip to his local shop and its pay-as-you-go photocopier was an integral part of his creative process. Even though Burrill finally relented and bought himself a computer, his love of the hand-made and found, 'non-designed' typefaces is still clearly apparent, in both his work for clients and his more personal artworks.

71

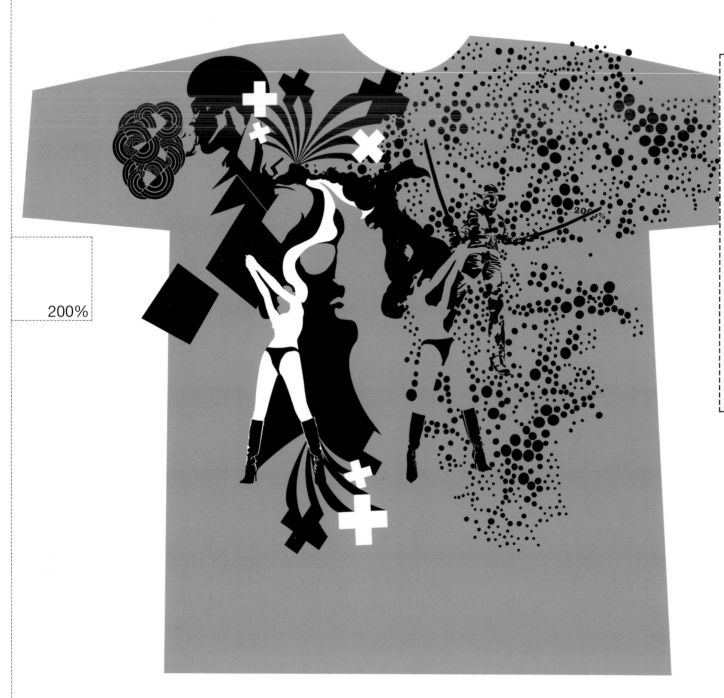

200%

Plus et Plus
www.plusetplus.com

Formed in 2002, Plus et Plus is a creative services studio based in New York. Working mostly in commercials, motion design and music videos, the company has worked with the likes of Nike and Laforet Tokyo while they have created T-shirt graphics for companies such as ARO and Swish. 'This design plays with the idea of two,' explains the studio's Judy Wellfare. 'Two people kissing, two go-go dancers, two explosions and two semi-obscured men, one holding two samurai swords.' The look was apparently inspired by 'psychedelic and spaghetti-western poster art'. *Design: Jeremy Hollister, Judy Wellfare, Jennifer Kim.*

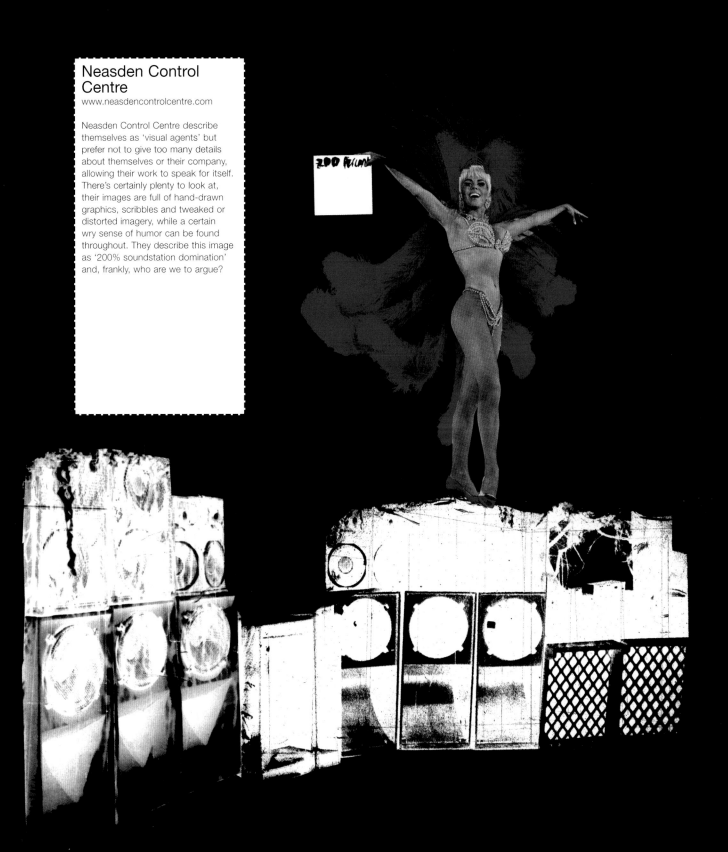

Neasden Control Centre
www.neasdencontrolcentre.com

Neasden Control Centre describe
themselves as 'visual agents' but
prefer not to give too many details
about themselves or their company,
allowing their work to speak for itself.
There's certainly plenty to look at,
their images are full of hand-drawn
graphics, scribbles and tweaked or
distorted imagery, while a certain
wry sense of humor can be found
throughout. They describe this image
as '200% soundstation domination'
and, frankly, who are we to argue?

Matthew Lenning
www.numberonedesign.com

Matthew Lenning took the humble cotton bud as his 200% starting point, thus neatly incorporating the book's title into his design. Based in New York, Lenning worked for a number of years as designer for the Condé Nast magazine *GQ*, but in 2003 he branched out on his own to found No.1, a design agency focusing on book and magazine-related projects. Apparently this design took Lenning himself by surprise. 'I usually handle things typographically,' he explains. 'But somehow I came up with this, which I would never have expected.'

200%

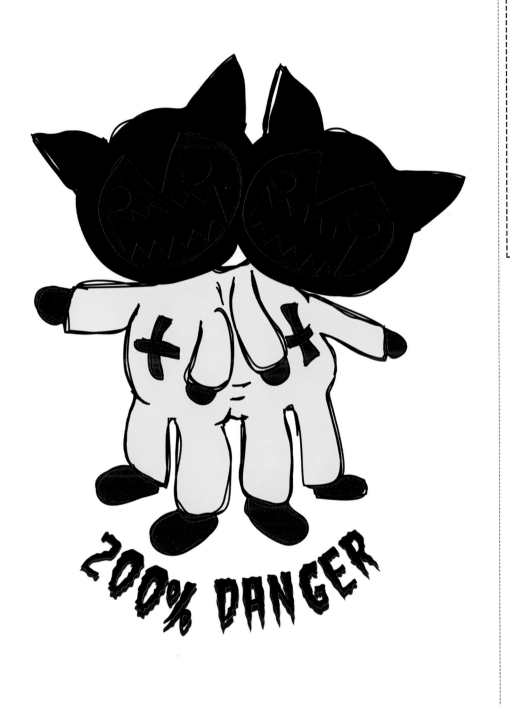

Danger
www.danger.uk.com

Monsters feature throughout the work of British clothing label Danger, generally made out of felt and stitched onto T-shirts. As such, it was only appropriate that one (two) should show up on Danger's 200% design. 'It's a 200% voltage overload for our version of Frankenstein's monster,' explains creator Ange Hayward. 'Lightning and electricity, a dangerous red and yellow explosion, and a scarily big-booted Frank.' (Frank, obviously, is the monster's delightfully unmonstrous name.)

Triboro

www.triborodesign.com

Founder and creative director of Brooklyn-based design agency Triboro, Dave Heasty decided to go one better than everyone else and redesign the T-shirt itself in order to answer our brief. Here, the T-shirt needs to start off at twice the required size (200%). Any would-be wearer needs to wash the garment first – on an extra hot setting. Then, as Heasty's label warns, the shirt will shrink by 50% in order to fit perfectly.

200%

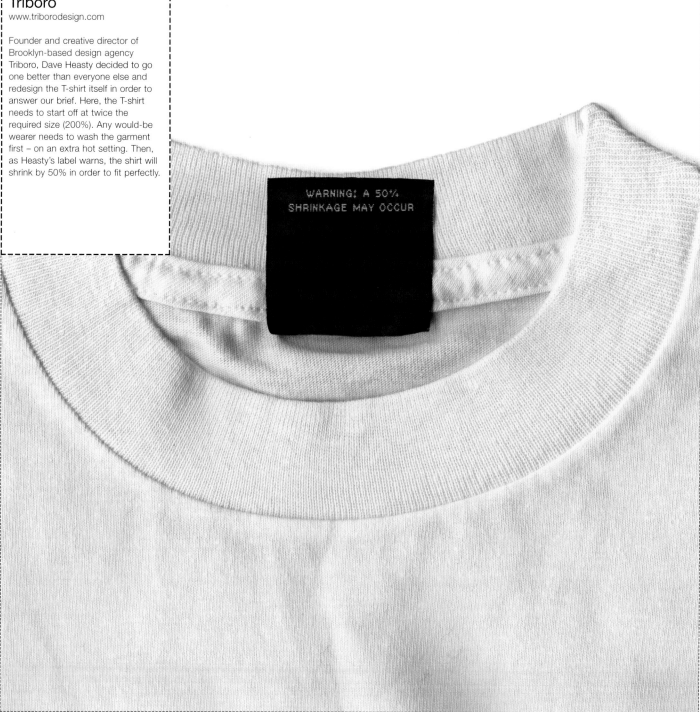

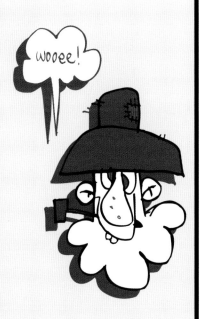

JAKe

London-based illustrator and designer JAKe works for a wide range of clients, including clothing labels and record companies. For the 200% design, he swears he tried to be sensible. 'I'd drawn that hick saying 'two hunnerd' right at the top of my first page of ideas,' he says. 'I kept on telling myself I couldn't use it because it'd be shown next to some-one suave, but all my other solutions were really wanky and I kept coming back to it.' We're happy he did, we like hicks and people who say 'wooee'.

200%

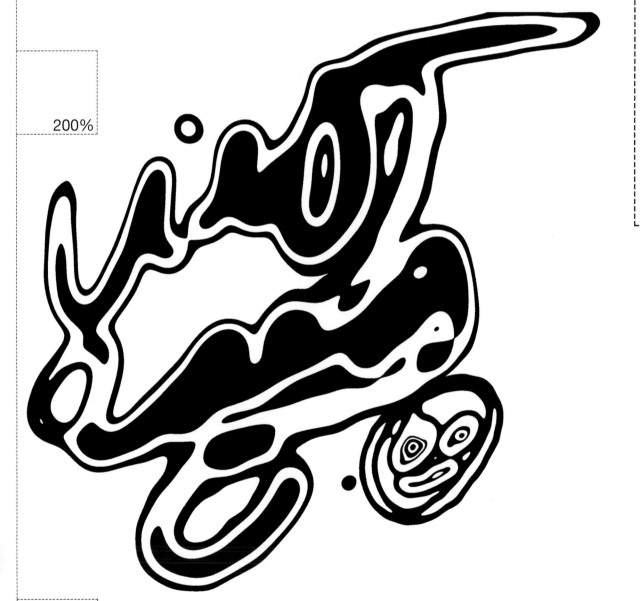

Vier5
www.vier5.de

'Our work aims to prevent any empty visual phrases and to replace them with individual, creative statements, which were developed especially for the used medium', says Achim Reichert of Paris-based design agency Vier5. 'For us, 200% means that something is much more than 100% ... more than is possible. Something that is bigger (or thicker) than the original. As such, we decided to find a simple motif and rework it. And as simple T-shirt motifs include a face and a word, we wrote "Vier5: 200%" and put a face on it. It's really very simple.'

an Wright
ww.mrianwright.co.uk

n Wright first came to prominence
the 1980s with his weekly illustra-
ons for the album reviews page of
ritish music paper, the *NME*. Since
hen, he has worked for numerous
gh-profile clients on jobs around
e world. Relentlessly experimenting
ith styles and materials, Wright
as created images using salt, hair,
ubber stamps, crayons and beads,
hile his artwork consistently displays
s sense of humour and love of the
diculous. The title of this image?
200% Headlock'.

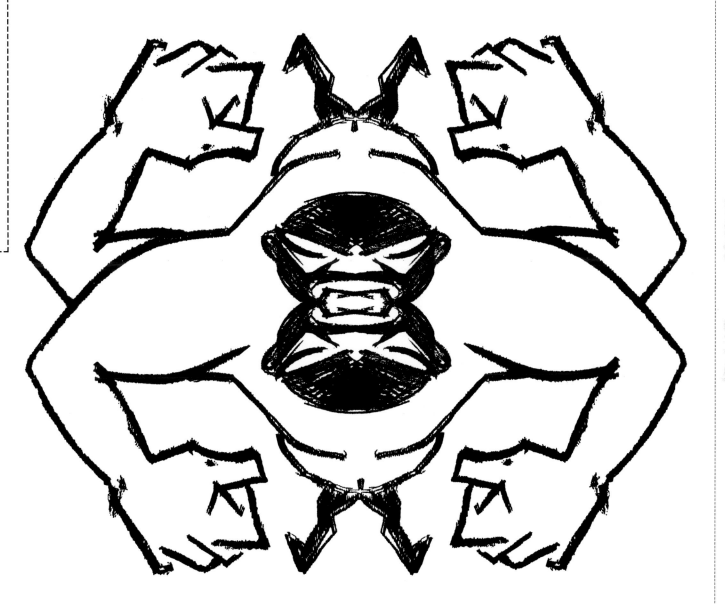

National Forest

www.nationalforest.com

'Our intention was to create a graphic that represented nature and its fertility', says Steven Harrington of Los Angeles-based design agency, National Forest. 'The reflection of the image gave it a better sense of balance, while at the same time complimented the 200% theme. We wanted the art to feel very tactile, as though it were drawn right on the T-shirt.'

200%

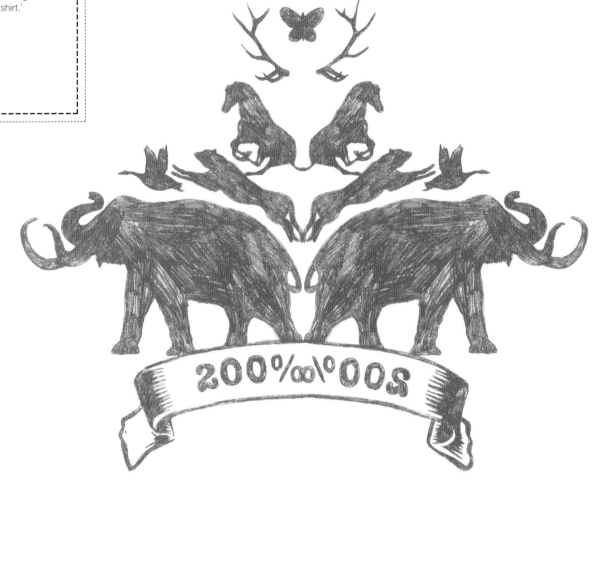

Tyler Askew

Slowly but surely, Tyler Askew has been making a name for himself with designs for the likes of *Straight No Chaser* magazine and various record labels, including Far Out, Spiritual Life and Quango. Originally from Atlanta, Georgia, Askew is now based in Brooklyn, New York. 'I wanted to utilize the overlooked iconography associated with cotton-based shirts', he says of this neat 200% design.

Machine wash warm, inside out, with like colors
Only non-chlorine bleach. Tumble dry medium.
Medium/hot iron. Do not iron decoration.
200% Cotton. Made in Brooklyn via London.

Oeuf

www.oeufworld.com

Andrew Hartwell started Oeuf in 1997, initially printing three 'very basic' T-shirts. Since then, he has continued to use T-shirts as a way of experimenting with printing techniques. 'There's a general 'lo-fi' approach to Oeuf and that's something I try to carry through all the designs', he explains. 'This particular graphic comes from listening to lots of elf-related music and thinking about the whole fantasy thing: something I've been into since I was at school. Oeuf loves elves', he concludes proudly.

200%

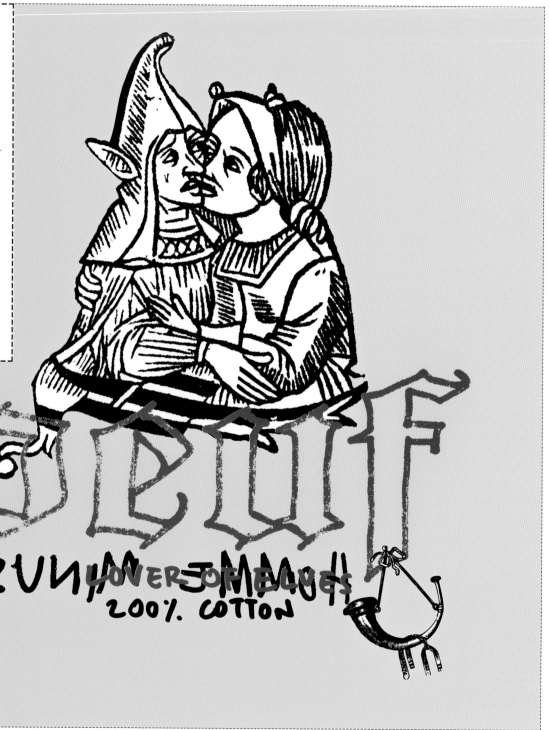

82

Nathan Gale

Perhaps not surprising from the author and designer of *Type 1*, a book devoted to digital typeface design, British art director Nathan Gale chose to tackle the 200% brief typographically. He created a modular typeface made up of percentage signs and then wrote the number 200 using, you guessed it, 200 per cent signs to do so.

MY GRANNY WENT
TO LONDON AND
ALL SHE GOT ME WAS
THIS LOUSY T-SHIRT.
THE FUCKING SKINFLINT.
I CAN'T STAND HER.
I'VE NEVER LIKED HER
SINCE SHE POURED
BOILING WATER ON ME,
WHEN I WAS A BABY.

200%

Scott King
www.scottkingltd.com

Former creative director of *Sleazenation* magazine, Scott King is currently something of an *enfant terrible* in the art world, exhibiting both solo work and his contributions to the Crash! collective. Delighting in producing work which features deliberately provocative imagery or slogans, King decided to play on well-known T-shirt terminology for the purposes of our brief. Nothing whatsoever to do with the 200% theme, but hey, not to worry. *'My Granny' T-Shirt, 2004. Courtesy Sonia Rosso, Torino, Italy*

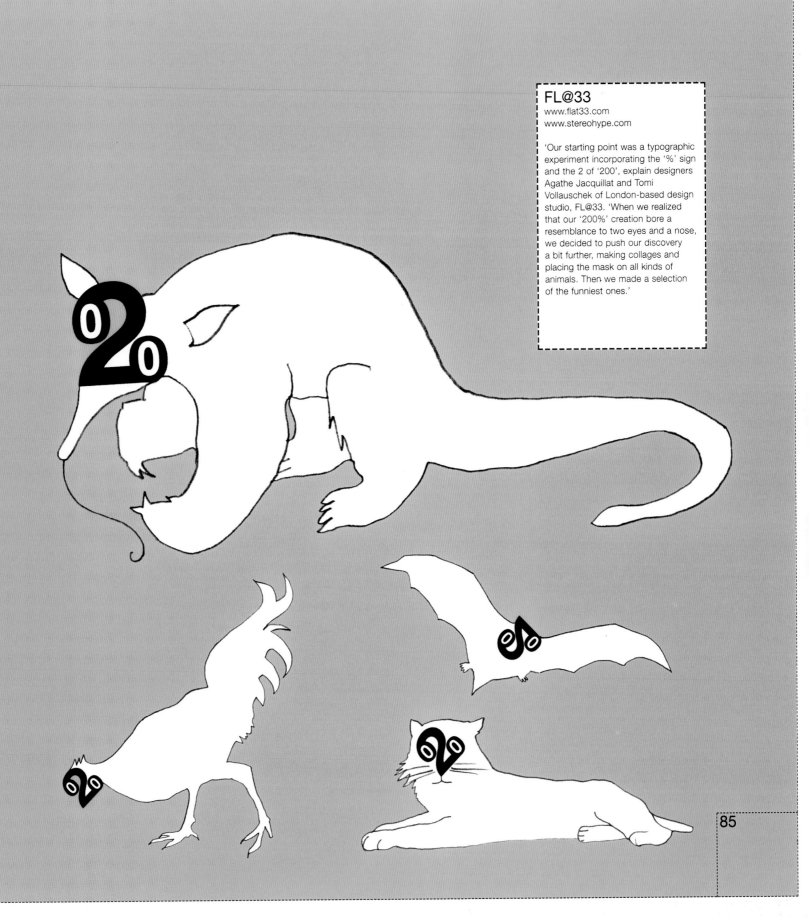

FL@33

www.flat33.com
www.stereohype.com

'Our starting point was a typographic
experiment incorporating the '%' sign
and the 2 of '200', explain designers
Agathe Jacquillat and Tomi
Vollauschek of London-based design
studio, FL@33. 'When we realized
that our '200%' creation bore a
resemblance to two eyes and a nose,
we decided to push our discovery
a bit further, making collages and
placing the mask on all kinds of
animals. Then we made a selection
of the funniest ones.'

LOVE

86

LOVE

You are not alone. Other people obsess about T-shirts and the graphics they are adorned with too. Here we celebrate the mania of a few who have taken it to a whole new level.

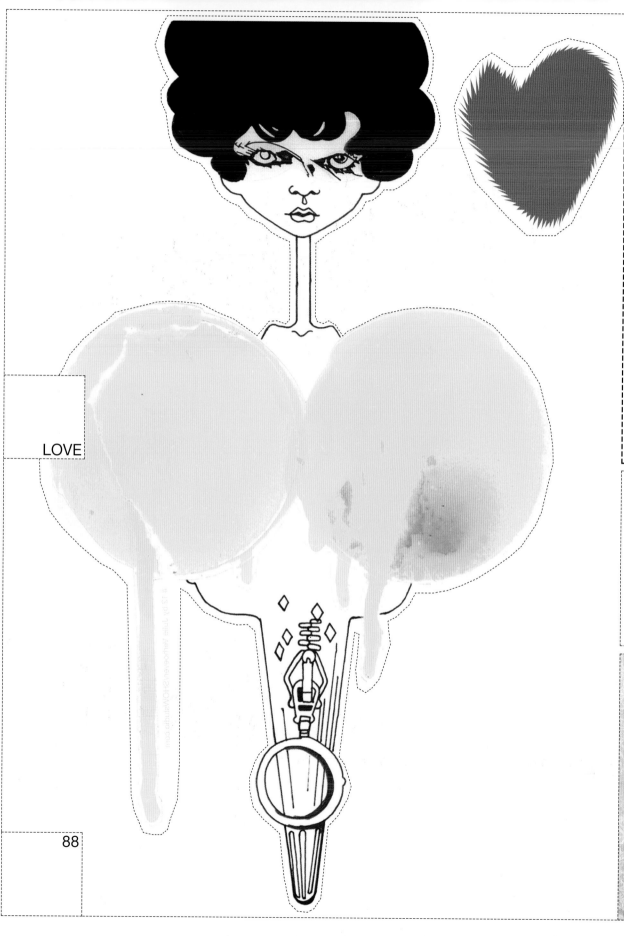

LOVE

88

SHOWstudio
www.showstudio.com

Acclaimed fashion photographer Nick Knight launched SHOWstudio.com in 2002 as an online space for leading creatives to make experimental, personal work. An ongoing project is the rather wonderful, *And All I Got Was This Lousy T-shirt,* for which some of those same creatives designed a T-shirt graphic. Provided as a downloadable PDF, the graphic is in handy back-to-front format, so that you can easily iron it onto a T-shirt of your choice.
Design (clockwise from left): Love Handles by Julie Verhoeven; Title = D by Frauke Stegmann; Skin Complaint by Nick Knight; Zero Tolerance by Judy Blame; Always & Forever by Maria Chen Pascual; On the Nick! by Jody Barton.

SKIN

POLLUTION
CORRUPTION
AMMUNITION
ISOLATION

ZERO TOLERANCE

dress aggression

COMPLAINT

SKINHEADS

Nathalie Zdrojewski

Nathalie Zdrojewski began taking pictures of people wearing music-related T-shirts in 2002. Before long, her project had become an obsession, with Zdrojewski advertising for willing subjects in shops all over London. 'I am obsessed with the notion of identity, how such a simple item of clothing can represent someone's identity and tastes', she explains. In 2003, together with illustrator and collaborator Joanna Beaumont, she organized a club night with a compulsory band T-shirt dress code. She now has about 500 pictures and no plans to stop taking them any time soon.

LOVE

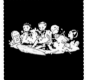

Yoko Devereaux
www.yokod.com

New York-based fashion label Yoko Devereaux coordinated this T-shirt-related exhibition, commissioning various designers to come up with a shirt based on the theme 'theft and stealing', which also happened to be Yoko Devereaux's own Spring 2004 collection theme. *Contributors: Yoko Devereaux, Bonus Magazine, Do Not Provoke Us, K48, Andrew Coulter Enright, Shigeru Suzuki, Surface to Air, Tony Moxham, English Kills, Ju$t Another Rich Kid, A. Spencer Product, Claudia Brown, Grant Shaffer, Adam Walko, Taavo Somer, Katrin Wiens, Star Electric 88, BFSO3, edit, H Fredriksson, the world of adam, Hungry Wives, Christauf Wright, Julian Hoeber, Trey Dapper, Troy Smith.*

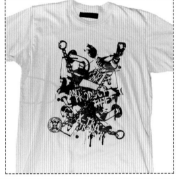

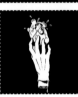

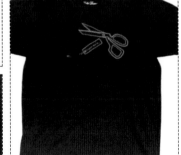

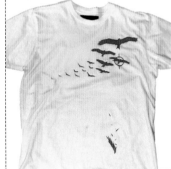

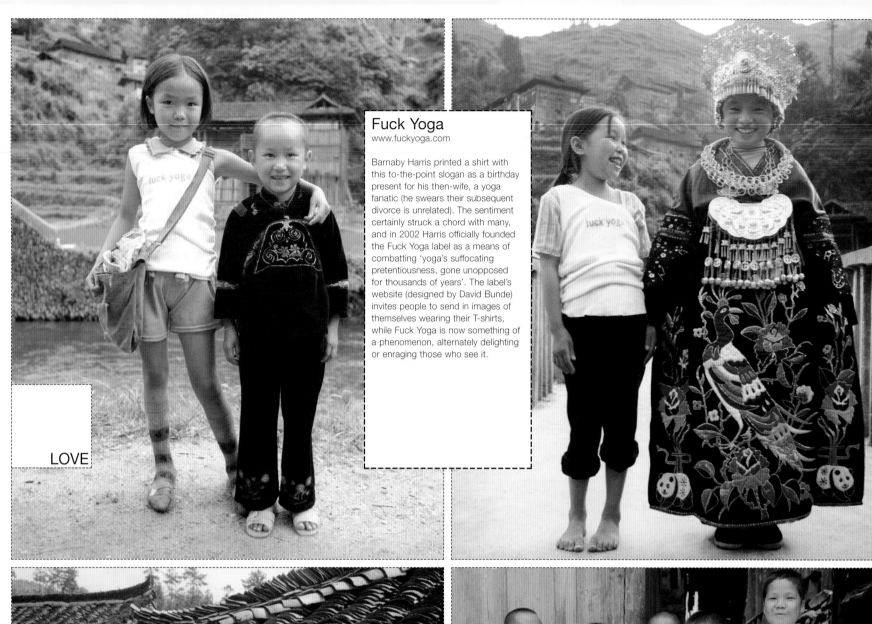

Fuck Yoga

www.fuckyoga.com

Barnaby Harris printed a shirt with this to-the-point slogan as a birthday present for his then-wife, a yoga fanatic (he swears their subsequent divorce is unrelated). The sentiment certainly struck a chord with many, and in 2002 Harris officially founded the Fuck Yoga label as a means of combatting 'yoga's suffocating pretentiousness, gone unopposed for thousands of years'. The label's website (designed by David Bunde) invites people to send in images of themselves wearing their T-shirts, while Fuck Yoga is now something of a phenomenon, alternately delighting or enraging those who see it.

LOVE

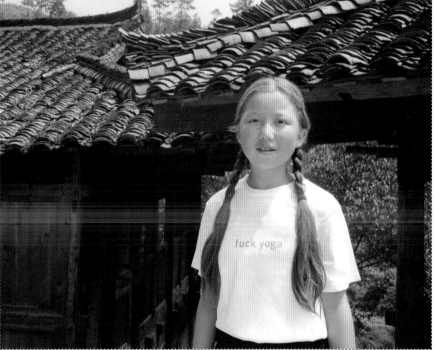

Pottymouth™

www.86theonions.com

Produced by Los Angeles-based brand communications collective, 86 the onions, the Pottymouth™ line of T-shirts exploits the fact that babies can't read. Styled as 'punk-rock clothing for punk-rock babies', the shirts were created as a deliberate, distinct alternative to Baby Gap, OshKosh B'Gosh and the like.
Creative director/writer: Chad Rea.
Art director/designers: Peter Vattanatham, Mark Sloan.

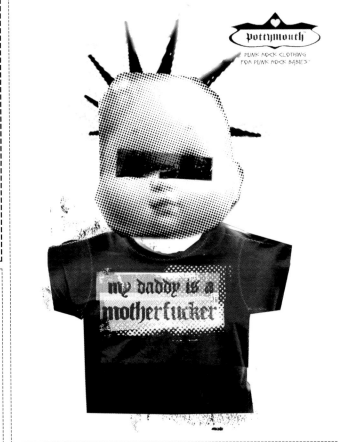

Fourskin
www.fourskinstore.com

Founded by Patrick, Jon and Eddie in 1998, Fourskin is a Singapore-based graphic fashion label 'created for designers by designers'. 'Fourskin aims to be an ever-evolving entity,' explains Patrick. 'We put forth ideas that revolve around collaborations with various artists and designers to promote, educate and inspire.' As such, they have collaborated on T-shirt related projects with the likes of graffiti artists 123 Klan (left) and David Kinsey (below) as well as producing their own collections of T-shirts (right).

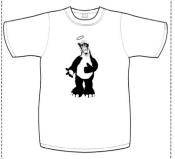

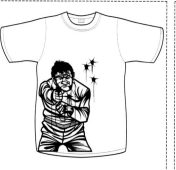

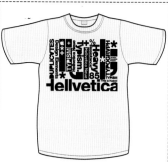

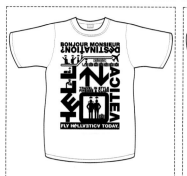

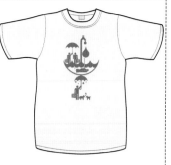

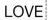

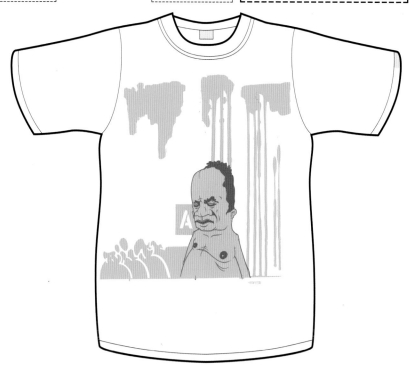

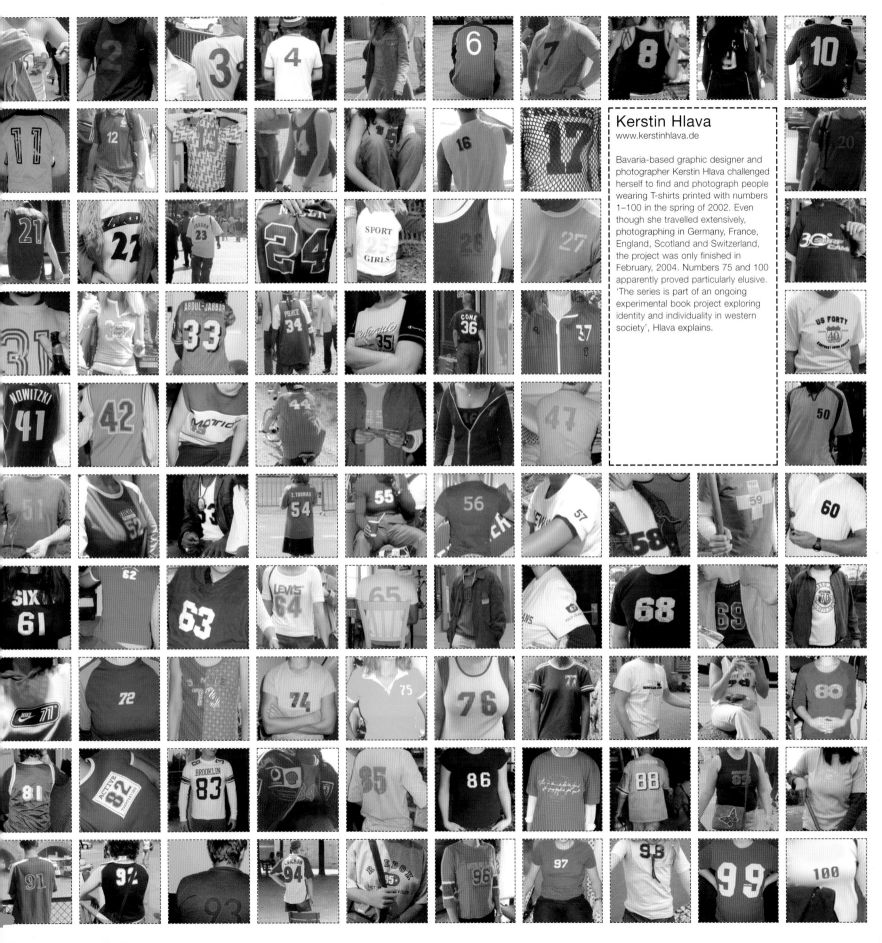

Kerstin Hlava
www.kerstinhlava.de

Bavaria-based graphic designer and photographer Kerstin Hlava challenged herself to find and photograph people wearing T-shirts printed with numbers 1–100 in the spring of 2002. Even though she travelled extensively, photographing in Germany, France, England, Scotland and Switzerland, the project was only finished in February, 2004. Numbers 75 and 100 apparently proved particularly elusive. 'The series is part of an ongoing experimental book project exploring identity and individuality in western society', Hlava explains.

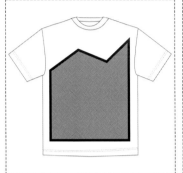

Pluto · Neptune · Uranus · Saturn · Jupiter · Mars · Earth · Venus · Mercury

Gas
www.gasweb.jp

Founded in 1996, Tokyo-based company Gas collaborates with artists, graphic designers and visual makers to produce design-oriented products, including books, DVDs, TV programmes and T-shirts. 'We provide themes like '1980s' culture' or 'favourite music' to artists and ask them to create graphic work inspired by that given theme', explains international editor/coordinator, Ayako Terashima. *Design (top row): Ukawa Naohiro, Laurent Fétis. Middle row: Experimental Jetset, Hiroshi Iguchi, Groovisions, åbäke. Bottom row: Reala, Blue Source, Tom Hingston Studio.*

LOVE

Sun

U.S.A.

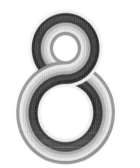

'By giving the designers the same theme, it enhances the individual characteristics of their style in an interesting way', Terashima continues. 'Our aim is to provide a platform for designers to express themselves fully.' They certainly invite some of the world's most interesting designers to contribute. *Design (clockwise from above): Ryan McGinness, Silvia Prada, Elisabeth Arkhipoff, Work in Progress, Vier5, Tomato, Frederique Daubal.*

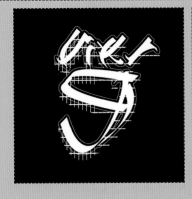

Warp Records
www.warprecords.com

British experimental electronic music label, Warp Records has a deserved reputation for collaborating with some of the world's foremost designers and directors, including the likes of Chris Cunningham and Alexander Rutterford. Their relationship with design agency The Designers Republic dates back to the label's early years, when it was still based in Sheffield in northern England. Their *Wrapt in Warp* event was held in a London gallery space in 2003 and showcased specially commissioned T-shirts by TDR, Dan Sparkes and Delta alongside live music and an exhibition of graphic artwork.

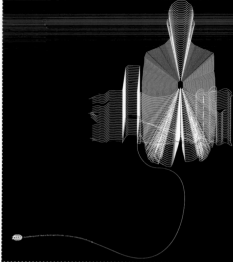

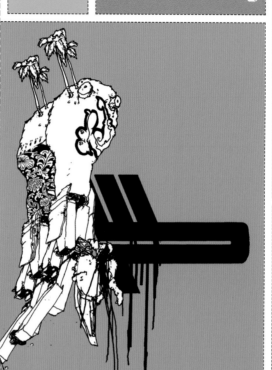

LOVE

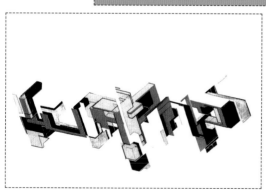

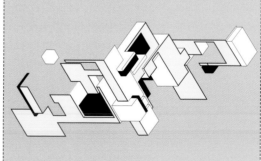

98

One-Brand Inc.
www.usa-t.com

'At an early age we all write a literary masterpiece on our home state,' says New York-based designer Todd Wilcox, the brains behind all-American brand USA-T.com. The site allows people to create their own shirt, featuring either the icon or bird of any of the fifty American states. 'Home Sweet Home,' concludes Wilcox proudly.

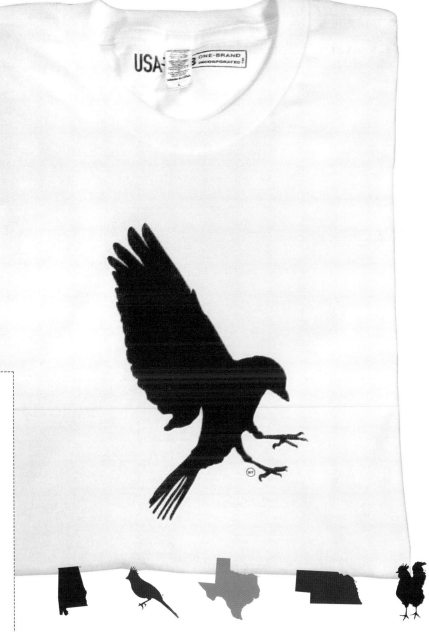

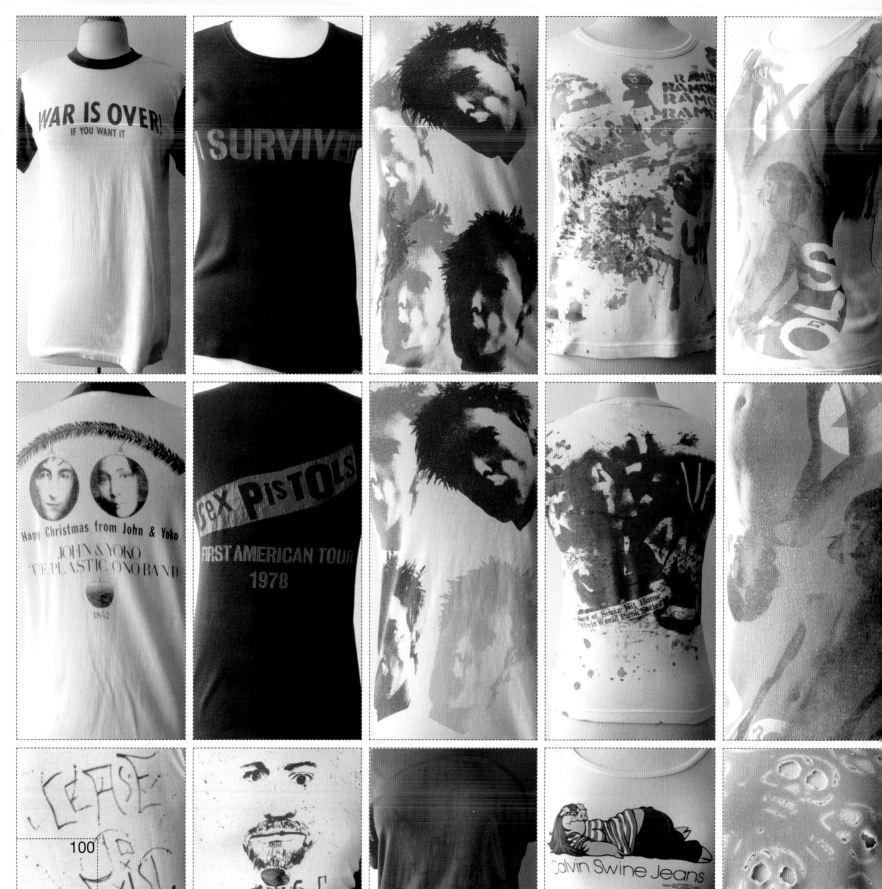

WAR IS OVER!
IF YOU WANT IT

I SURVIVED

Happy Christmas from John & Yoko

JOHN & YOKO
THE PLASTIC ONO BAND

1842

SEX PISTOLS

FIRST AMERICAN TOUR
1978

Calvin Swine Jeans

100

AKA JESUS C.

Cesar Padilla
www.cherryboutique.com

Cesar Padilla has been buying punk-rock related T-shirts since the late 1970s, but he became entirely obsessive in his quest to find more after his horrified mother threw away his collection in 1988. Now he not only sells vintage shirts directly from his stores, the Cherry boutiques in New York and Los Angeles, he also hires out shirts to anyone wanting a slice of authenticity (for a limited time period only). His carefully curated collection includes extremely rare and one-off pieces of vintage musical history, the most expensive of which would set you back 'a five digit sum'. *Photography: Dustin Ross.*

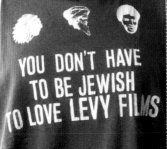

Snob

Designer David Carrewyn decided to mock the 'must-have' value of certain brands by starting his own T-shirt line, Snob. But, instead of trying to promote the label anywhere and everywhere, Carrewyn limited production to fifty of each design, which he then gave to high-profile friends to wear and create a demand that could never be fulfilled. 'We poked fun at the "really-hard-to-find-obscure-T-shirt" cliché by exaggerating the idea into "hard to find because it isn't even for sale"', he explains mischievously. A related project saw him persuading some homeless people in Brussels to be photographed wearing the T-shirts, with the images forming part of a touring exhibition. Carrewyn insists that there was no hint of exploitation: 'We traded the shot for two beers,' he says. 'These guys would have done way more for way less!'
Photography: Jean-Charles Dherville.

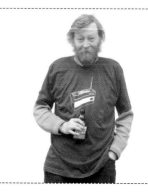

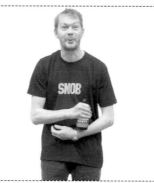

LOVE

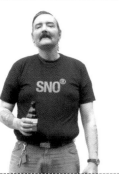

SNO®

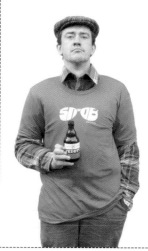

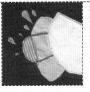
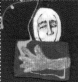

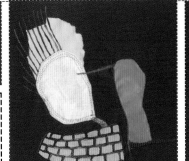
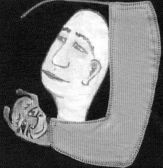

No Company
www.nocompany.com

Toronto-based artist Jess Perlitz started No Company in 2002 'as a way to involve people in the creative process'. Participants simply answer a series of twenty-one questions (including 'Which animal would you choose to be this person's familiar?' and 'Do you know what this person is like when they're angry?'). Then they give Perlitz the name and address of someone they want to receive a hand-printed T-shirt and let her do the rest. Her interpretations of your answers are utterly abstract but the filled-out questionnaire is also included in the parcel, so the gift recipient can see what you wrote.

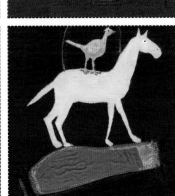

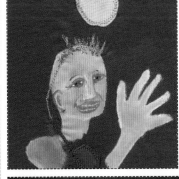
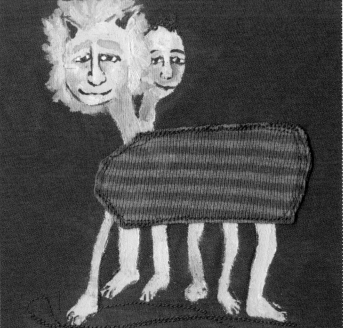

SELL

104

SELL

The T-shirt has been used as an ideal promotional vehicle since way back when. Here we celebrate brands and designers using the T-shirt as a modern-day equivalent of the sandwich board. Well let's face it, it's a darned sight more convenient.

2K
www.2ktshirts.com

Japanese/American company 2K commissions some of the world's most innovative designers to produce their T-shirt graphics, allowing them considerable creative freedom. Featured below is the Dead Format Series by British design agency Build. 'I wanted to document the disappearance, and in the case of the VHS cassette, the imminent disappearance of everyday objects that I grew up using', explains the studio's Michael C. Place. Also shown (right) are two shirts designed by Brooklyn-based graffiti writer and artist, James Marshall (aka Dalek.) 'Space monkeys are a reflection of humans and all the subtleties that make us the absurdly entertaining creatures we are', he says of his faintly demonic-looking characters.

Dead format series
Compact Audio Cassette. Produced: 1963.
Shown at 87.5 percent actual size.

Dead format series
VHS [Video Home System] Cassette. Produced: 1976.
Shown at 58.4 percent actual size.

Dead format series
3.5" [HD] High-Density Floppy Disk. Produced: 1981.
Shown at 67.5 percent actual size.

Disassembled.

Magnetic Media.

1.44MB.

We Are Build.

HD
02 of 03 Dead Format Series™

National Forest

www.nationalforest.com

Steven Harrington and Justin Krietemeyer of Los Angeles-based design agency, National Forest, apply their love of a hand-made aesthetic to T-shirt graphics for a number of clients, including the record label Ubiquity. Taking inspiration from anything and everything, the pair describe their work as 'like a mix tape made for a friend. It's a collection of favorite moments that we want to share.'

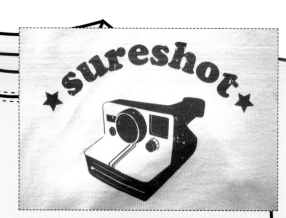

SELL

onepom
www.onepom.com

Richard Kirk and Elisabeth Lecourt founded the design agency onepom in 2002. Together the pair work across media for a variety of international commercial clients, including Evian, Carlsberg and the BBC. Recently, they founded Monopé (www.monope.com), a graphic design and fashion boutique based in Paris. 'The idea is to showcase and sell unique posters, magazines, books, screen-printed T-shirts, toys and artworks by inspirational graphic designers, illustrators, design groups and artists from around the world', says Lecourt of the new venture. *Designs shown here: onepom for Monopé.*

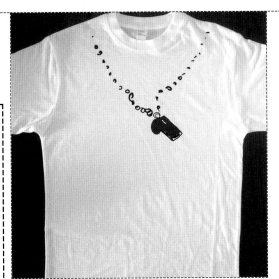

Umbro
www.umbro-contrast.com

Soccer brand Umbro commissioned the fashion world's newest rising star, Kim Jones, to design the debut collection of a new line, Contrast, which launched in Spring/Summer 2004. Featuring clothes for both men and women, Jones's playfully illustrated T-shirts with the cheeky catchline 'I won't sit still' were a genuine highlight.

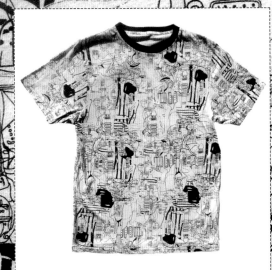

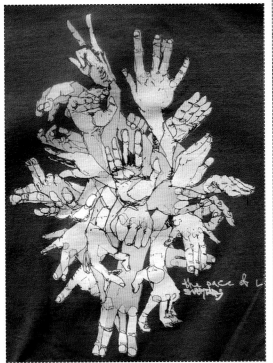

Levi's
www.levi.com

Denim giant Levi's has not been slow to pick up on the recent surge in enthusiasm for graphic T-shirts, while they have been smart enough to commission their graphics from a host of international, cutting-edge artists. By doing this, the theory goes, the brand can pick up some valuable cool points by default. *Design (top to bottom, left to right): Dave Choe; Joel Lardner; Dave Choe; Frank Kozik; Shepard Fairey; Joel Lardner.*

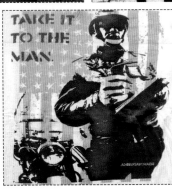

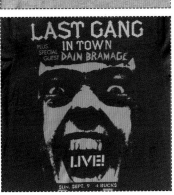

111

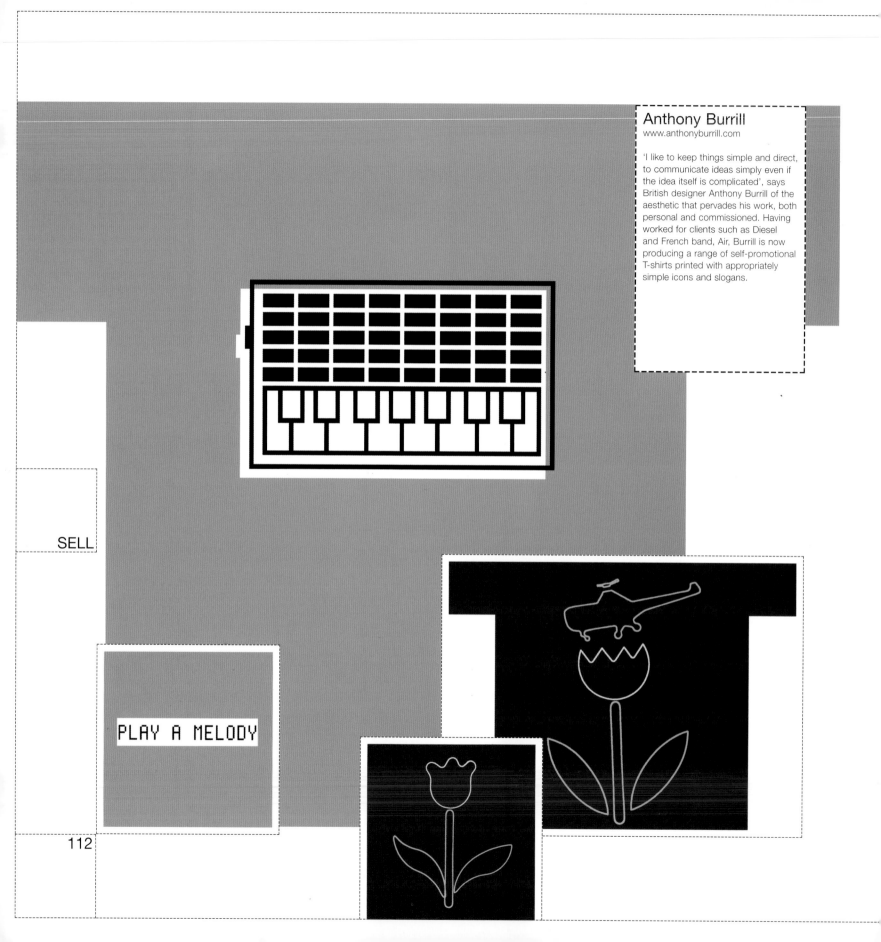

PLAY A MELODY

Anthony Burrill
www.anthonyburrill.com

'I like to keep things simple and direct, to communicate ideas simply even if the idea itself is complicated', says British designer Anthony Burrill of the aesthetic that pervades his work, both personal and commissioned. Having worked for clients such as Diesel and French band, Air, Burrill is now producing a range of self-promotional T-shirts printed with appropriately simple icons and slogans.

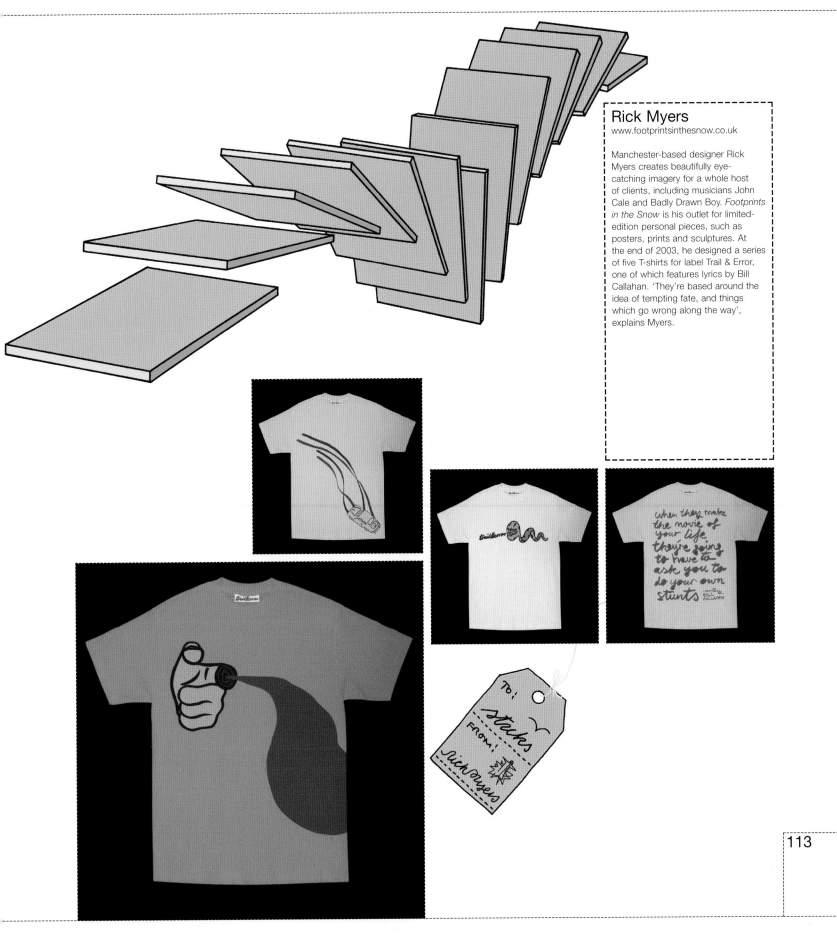

Rick Myers
www.footprintsinthesnow.co.uk

Manchester-based designer Rick Myers creates beautifully eye-catching imagery for a whole host of clients, including musicians John Cale and Badly Drawn Boy. *Footprints in the Snow* is his outlet for limited-edition personal pieces, such as posters, prints and sculptures. At the end of 2003, he designed a series of five T-shirts for label Trail & Error, one of which features lyrics by Bill Callahan. 'They're based around the idea of tempting fate, and things which go wrong along the way', explains Myers.

The Money Kids
www.themoneykids.com

The Money Kids are Herb George, Jeff Canham and George Covalla. Based in New York, the company works across media to 'conceptualize, direct, create and produce.' Working predominantly with cool streetwear labels, they have created T-shirt graphics for the likes of Stüssy and the sunglasses line, Von Zipper.

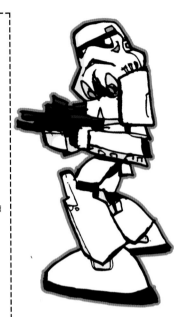

JAKe

Born in Hull, illustrator and designer JAKe now lives and works in east London. 'I have been plastering scratchy images over every available surface since my first box of Crayola', he says. 'The first of my T-shirt designs that anyone really paid any attention to was for The Prodigy. It was subsequently bootlegged in quite astonishing amounts.' Working from the DETONATOR studio, these T-shirts were commissioned by Lucaslicensing to capitalize on new interest in the *Star Wars* films sparked by the release of the film *The Phantom Menace*. © 2003 Lucasfilm Ltd & TM.

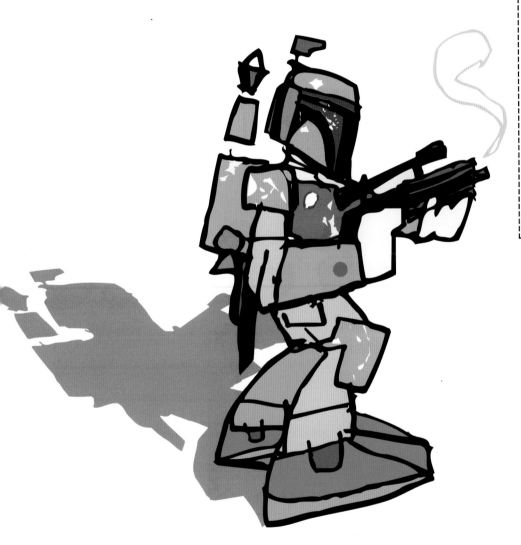

Stephen Bliss

www.stephenbliss.com

Stephen Bliss works at Rockstar Games in New York, working on titles such as *Grand Theft Auto 3* and *Vice City*, designing packaging, posters and the occasional promotional T-shirt. 'For T-shirts I generally stick to my own brief, which seems to be if I'd wear it then someone else might', he says.

Fluid

www.fluidesign.co.uk

Birmingham-based design company Fluid was commissioned to create some simple, two-colour T-shirts to promote the game *Resident Evil Dead Aim*. They used elements which had already been introduced in the advertising and packaging – 'with the addition of a few smears of blood'.

SELL

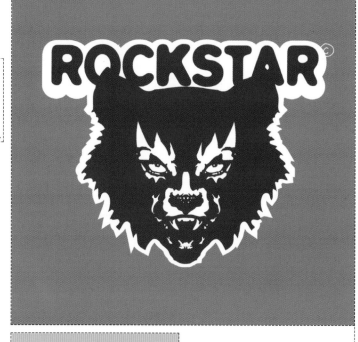

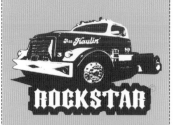

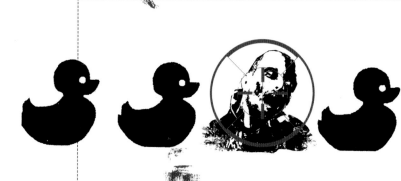

Greedy Gas Guzzlers
www.greedygasguzzlers.com

New Zealand-born, New York-based artist and designer Matt Campbell conceived Greedy Gas Guzzlers as a 'pop-culture attack on the forces of corporate and consumer greed that are increasingly conspiring to choke mother nature out of existence'. Campbell uses humour and irony to make his points, producing prints and toys alongside limited edition T-shirts. Guest artists have also contributed images, including Mike Davison, whose take on the American flag, 'Peace Patch', is shown here.

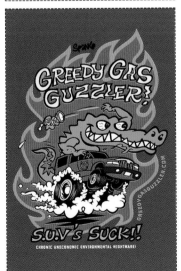

Shynola

www.shynola.co.uk

Probably better known for their animation and promo direction for bands including Radiohead, Blur and Queens of the Stone Age, Shynola decided to create a range of T-shirts for the sheer, self-promotional hell of it. Or as they put it: 'these shirts are a chance for us to have some fun and create for pleasure. Plus now we always have a clean change of shirt at the office.'

SELL

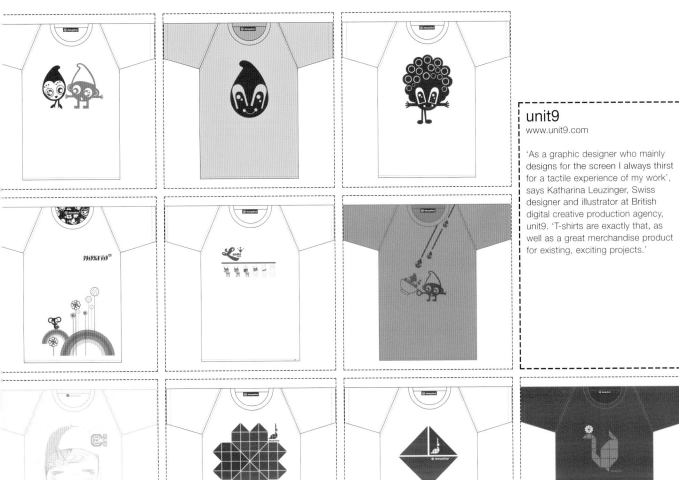

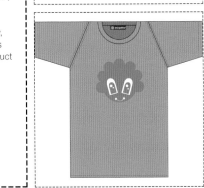

unit9
www.unit9.com

'As a graphic designer who mainly designs for the screen I always thirst for a tactile experience of my work', says Katharina Leuzinger, Swiss designer and illustrator at British digital creative production agency, unit9. 'T-shirts are exactly that, as well as a great merchandise product for existing, exciting projects.'

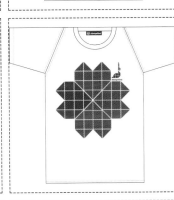

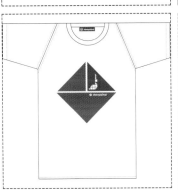

Keep Left Studio
www.kleft.com/studio

Based in Sydney, Australia, Keep Left
Studio takes on film, print and inter-
active projects, with their client roster
including the likes of Nike, Playstation
and MTV. They have produced T-shirt
graphics for clients such as Split,
Mooks, Sunday First Aid Japan and
Recoil, while the studio's Luca Ionescu
also runs his own fashion label, Hektik.
*Design: Luca Ionescu, Kevin Vo
and Michelle Hendriks.
January 2002–December 2003.*

front

back

sleeve detail

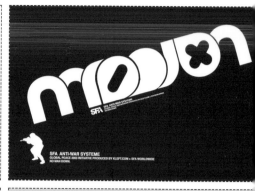

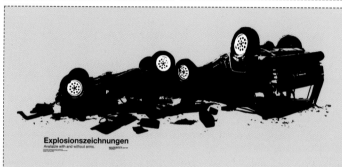

SELL

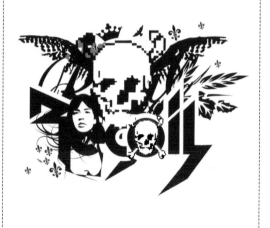

front

back

WEAPONSOFMASSDESTRUCTION

Beat13

www.beat13.co.uk

Beat13 was formed in 1999 by a
group of friends who decided to
put on shows of their graphics and
illustration work. Such was their
success that they launched their own
gallery in Birmingham in late 2002,
for which they produce a range of
T-shirts. 'It is only natural to want to
see your designs on people's bodies,'
they explain. 'T-shirts are a first step
in blatant self-promotion.' *Design:
Lucy Mclauchlan, Al Murphy, Matt
Watkins. Photography: Tajinder
Sandhu, Matt Watkins.*

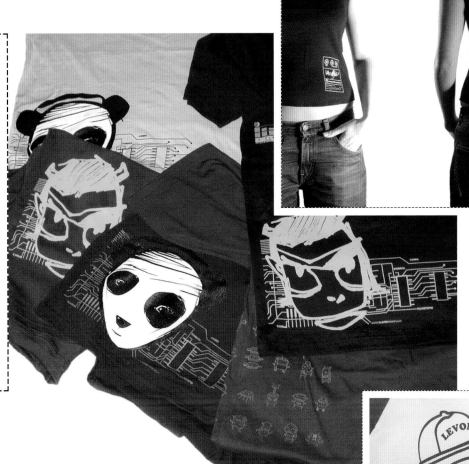

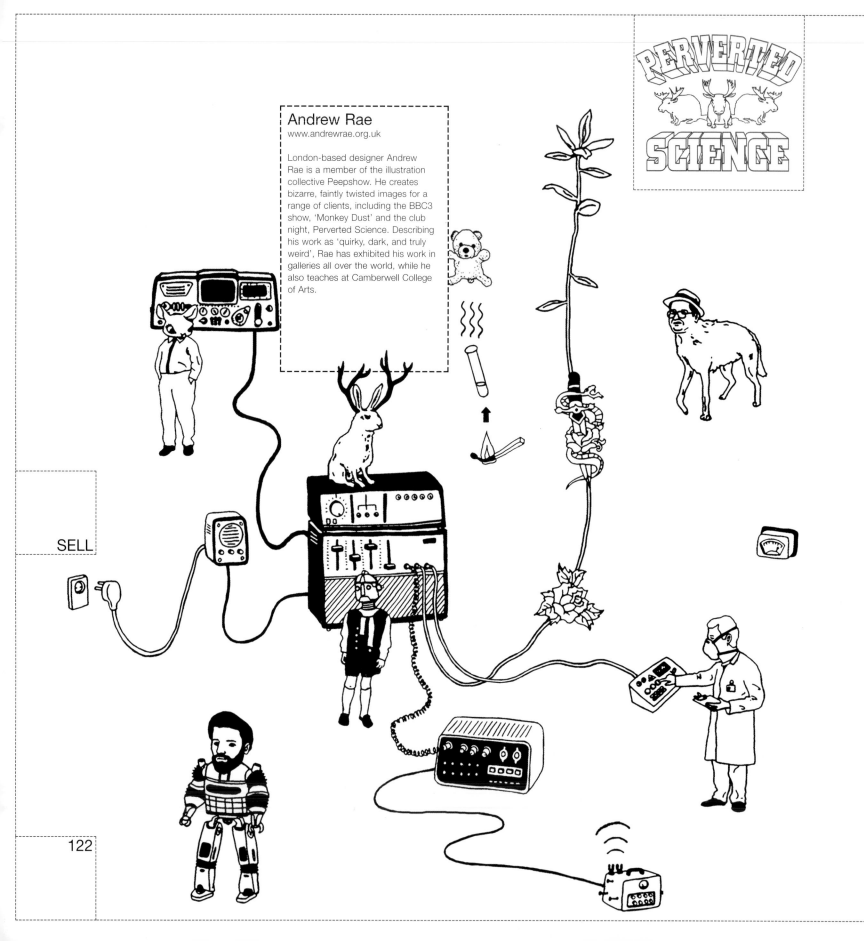

Andrew Rae
www.andrewrae.org.uk

London-based designer Andrew
Rae is a member of the illustration
collective Peepshow. He creates
bizarre, faintly twisted images for a
range of clients, including the BBC3
show, 'Monkey Dust' and the club
night, Perverted Science. Describing
his work as 'quirky, dark, and truly
weird', Rae has exhibited his work in
galleries all over the world, while he
also teaches at Camberwell College
of Arts.

SELL

Andrew Hanson's F
www.andrewhansonsf.net

Los Angeles label Andrew Hanson's F was born in 1998, after Hanson 'woke up and made a shirt inspired by the music of the Sex Pistols.' Echoing the do-it-yourself philosophy of punk, every shirt is handmade with absolutely none of the design elements left to chance. 'Andrew Hanson's F isn't just another T-shirt brand that has a spark of an idea and is here for the quick cash and the moment,' he explains. 'The ethos is simple: Wear whatever the hell you look good in, and don't worry about Joan.'

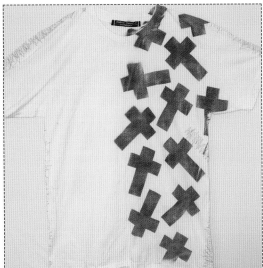

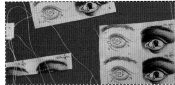

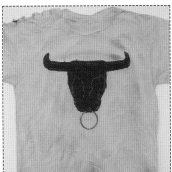
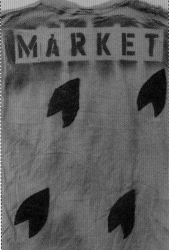

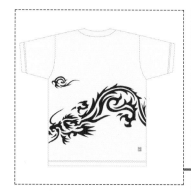

Zakka Corporation
www.zakkacorp.com

Based in New York, Zakka is both a shop and an artists' space, featuring graphic art-related books, clothes, music and stationery. In 2003, they launched their own brand of T-shirts, Zakka+NYC, for which they commission well-known designers such as Ryan McGinness, Non-conceptual and Deanne Cheuk to create the graphics. Their overall identity is overseen by the 'visual creators' collective', Z-graphix, whose work is shown here.

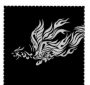
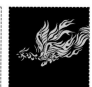

SELL

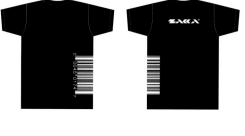

central park nyc

central park nyc

CENTRAL PARK

TENNIS CLUB

CENTRAL PARK

ROLLER BLADING

NYC 2003

CENTRAL PARK

NYC USA

JOGGING

CENTRAL PARK

nyc 2003

PLAYGROUND POSSE

designing | eating | sleeping

www.designingeatingsleeping.com

Founded in 2001 by Liza Pagano and William Hadley, designing | eating | sleeping work across media to create eye-catching but appropriate designs for a range of clients. These include New York's Central Park Conservancy, for which they designed this range of T-shirts to celebrate the park's 150th anniversary in 2003.

THE
RESERVOIR

THE
DAIRY

THE
HARLEM
MEER

STRAWBERRY
FIELDS

bethesda fountain
central park | nyc

Central Park
Bug Patrol Tracking bugs for 150 years

CENTRAL PARK DOGS

150 YEARS OF DOGS IN THE PARK

BETHESDA FOUNTAIN
CENTRAL PARK
NYC

Central Park

Fishing School
NYC

Central Park
New York City

BOATING
since. 1930

GH avisualagency™

www.ghava.com

GH avisualagency™ comprises five designers who all met while living, studying and working in Atlanta, Georgia. Four of them (Sadek Bazaraa, Randall Lane, Derek Lerner and David Merten) now live and work in Brooklyn, while the fifth (Peter Rentz) is based in Los Angeles. Formerly known as Graphic Havoc, the collective has worked for a wide range of clients, including adidas, Triple Five Soul and Nike, while they have also produced various self-promotional T-shirts featuring their distinctive, eye-catching illustrations and graphics.

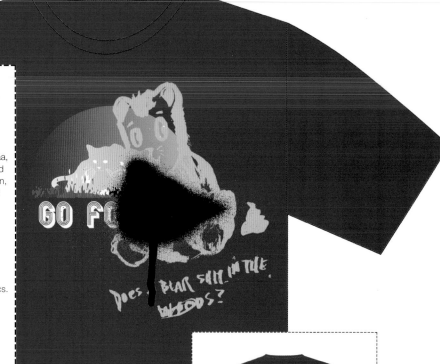

SELL

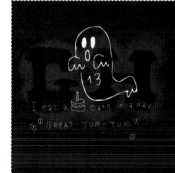

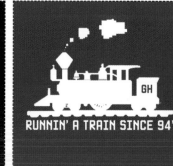

Mode 2

www.picturesonwalls.com

Graffiti artist Mode 2 has been printing and producing graphic T-shirts since 1992, but he has worked for a wide range of advertising and editorial clients, including Carharrt and Harri Peccinotti. While many of his earlier shirts featured graphics relating to his continued obsession with hip-hop music, Mode 2 recently decided to express how awful he thinks London is. His personally-produced, slogan-based shirts are undeniably to-the-point, and a world away from the portraits of buxom women for which he is probably most famous.

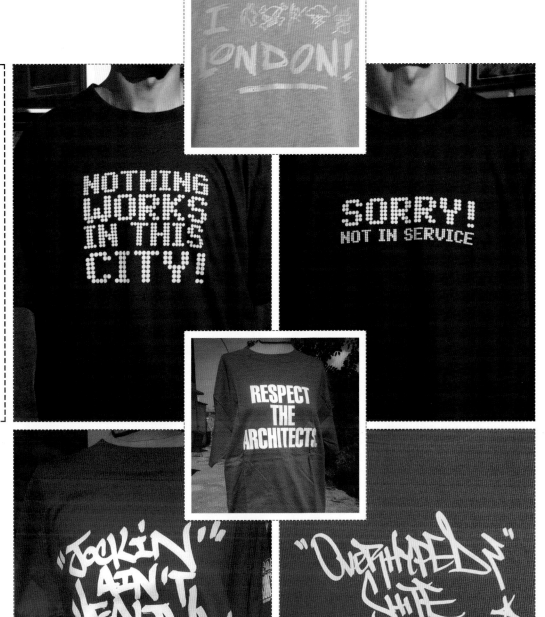

Neasden Control Centre

www.neasdencontrolcentre.com

'Multi-disciplined northerners working in visual communication for individuals and companies on earth' is how the founders of London-based design agency Neasden Control Centre describe themselves. They are certainly prolific: clients to date include magazine *XLR8R*, band Wevie Stonder, record label Island Records and clothing line O-6-N, for which they designed a range of graphic T-shirts. They are no slouches in the self-promotion department either, designing and printing T-shirts with their inimitable style of graphics.

O6N

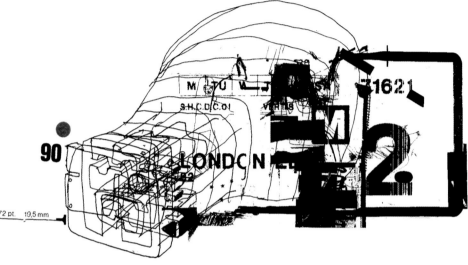

SELL

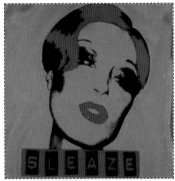

Some Product
www.someproduct.com

Established in 1994, Vancouver-based agency Some Product is involved in production, promotion, photography, graphics and clothing design, producing regular collections of T-shirts. 'There isn't a particular ethos to the design,' explains the label's Dave Briker. 'Except that it should appeal on a visual level with an allusion to humor, irony and/or tastelessness.' *All designs by Dave Briker except High Class, Salon and Let's Get High, by Dave Briker and Danny Fazio.*

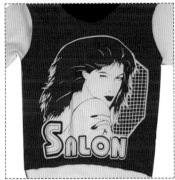

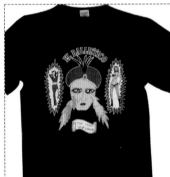

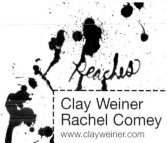

Clay Weiner
Rachel Comey
www.clayweiner.com

New York-based designers Clay Weiner and Rachel Comey were commissioned by the delightfully provocative musician Peaches to design some T-shirts for the singer's tour. 'I went off in different directions,' says Weiner of the resulting designs. 'But my favorite one was probably the armpit hair T-shirt. I was adamant about us producing that one. Logically, I thought it could lead to Peaches being asked to endorse deodorant.' Now there's an idea.

SELL

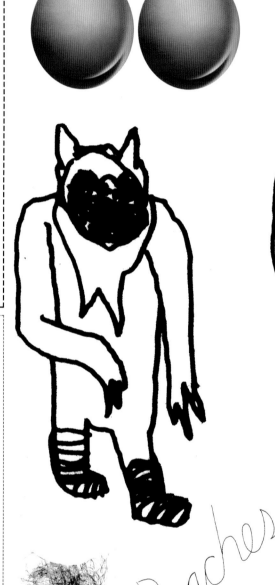

Peaches

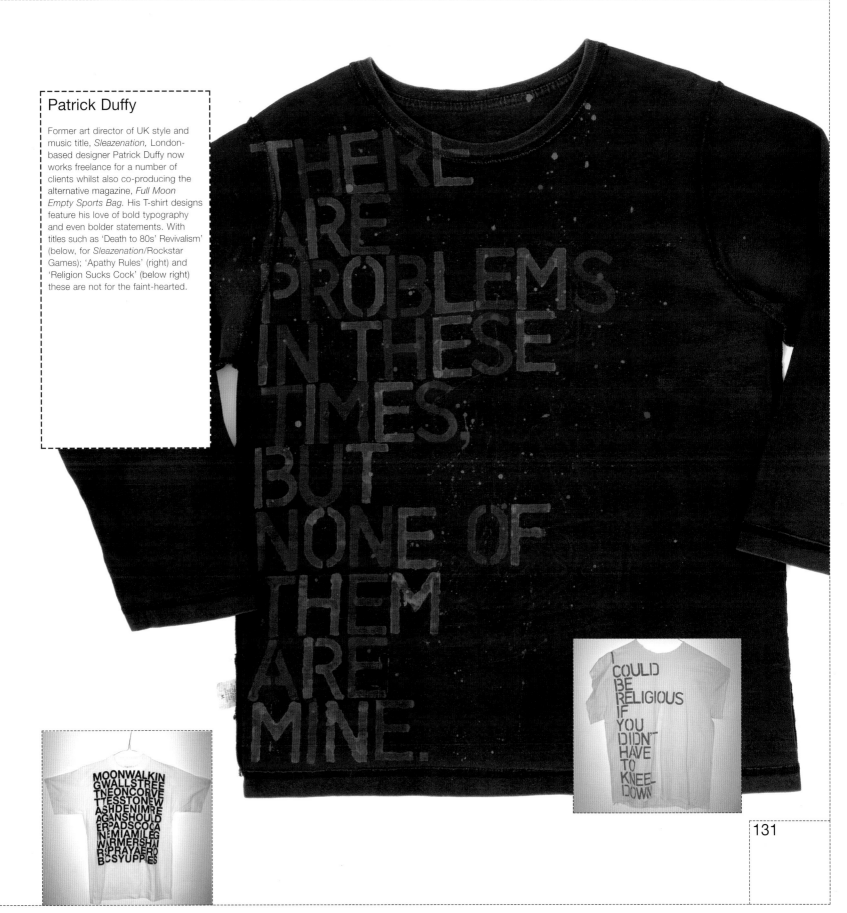

Patrick Duffy

Former art director of UK style and music title, *Sleazenation,* London-based designer Patrick Duffy now works freelance for a number of clients whilst also co-producing the alternative magazine, *Full Moon Empty Sports Bag.* His T-shirt designs feature his love of bold typography and even bolder statements. With titles such as 'Death to 80s' Revivalism' (below, for *Sleazenation*/Rockstar Games); 'Apathy Rules' (right) and 'Religion Sucks Cock' (below right) these are not for the faint-hearted.

THERE ARE PROBLEMS IN THESE TIMES, BUT NONE OF THEM ARE MINE.

MOONWALKIN GWALLSTREE TNEONCORVE TTESSTONEW ASHDENIMRE AGANSHOULD ERPADSCOCA INEMIAMILEG WARMERSHI R&PRAYAERO BICSYUPPIES

I COULD BE RELIGIOUS IF YOU DIDN'T HAVE TO KNEEL DOWN

Che! Light

Che! Roman

Staple Design
www.stapledesign.com

With offices in New York and Tokyo, Staple Design acts as a design and branding consultancy to a number of clients wanting to attract a more discerning, edgy consumer. Rather than talk about their deep understanding of this market, Staple instead decided to produce their own line of clothing, which they now sell in their own gallery space/store. It's smart, persuasive thinking which wins over potential clients a million times more effectively than yet another PowerPoint presentation. *Design: Jeff Ng, Aki Carpenter, Ai Fukasawa, Jerry Hsiao, Mariko Iwata, Hiromi Oda, Tom Ran, Nico Reyes, Miles Skinner, Jun Sugai.*

Che! Bold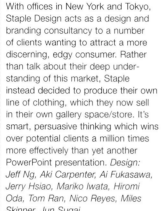

Che! Italic

Che! Extended

Che! Condensed

Che! Outline

SELL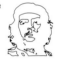

Che! Dingbats

Little Boy ❈ *Fat Man*

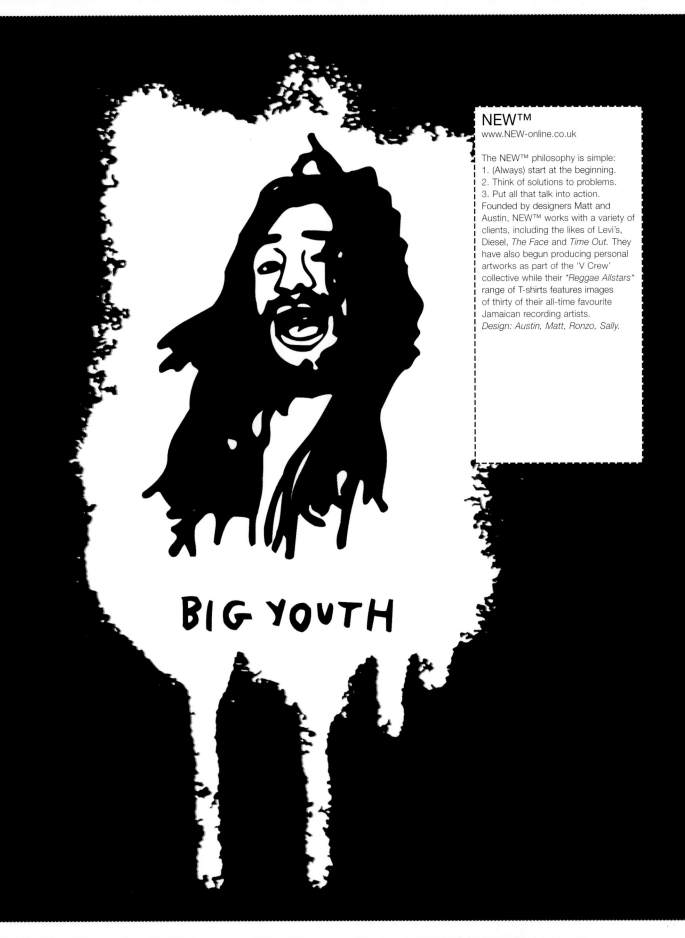

BIG YOUTH

NEW™
www.NEW-online.co.uk

The NEW™ philosophy is simple:
1. (Always) start at the beginning.
2. Think of solutions to problems.
3. Put all that talk into action.
Founded by designers Matt and
Austin, NEW™ works with a variety of
clients, including the likes of Levi's,
Diesel, *The Face* and *Time Out*. They
have also begun producing personal
artworks as part of the 'V Crew'
collective while their *Reggae Allstars*
range of T-shirts features images
of thirty of their all-time favourite
Jamaican recording artists.
Design: Austin, Matt, Ronzo, Sally.

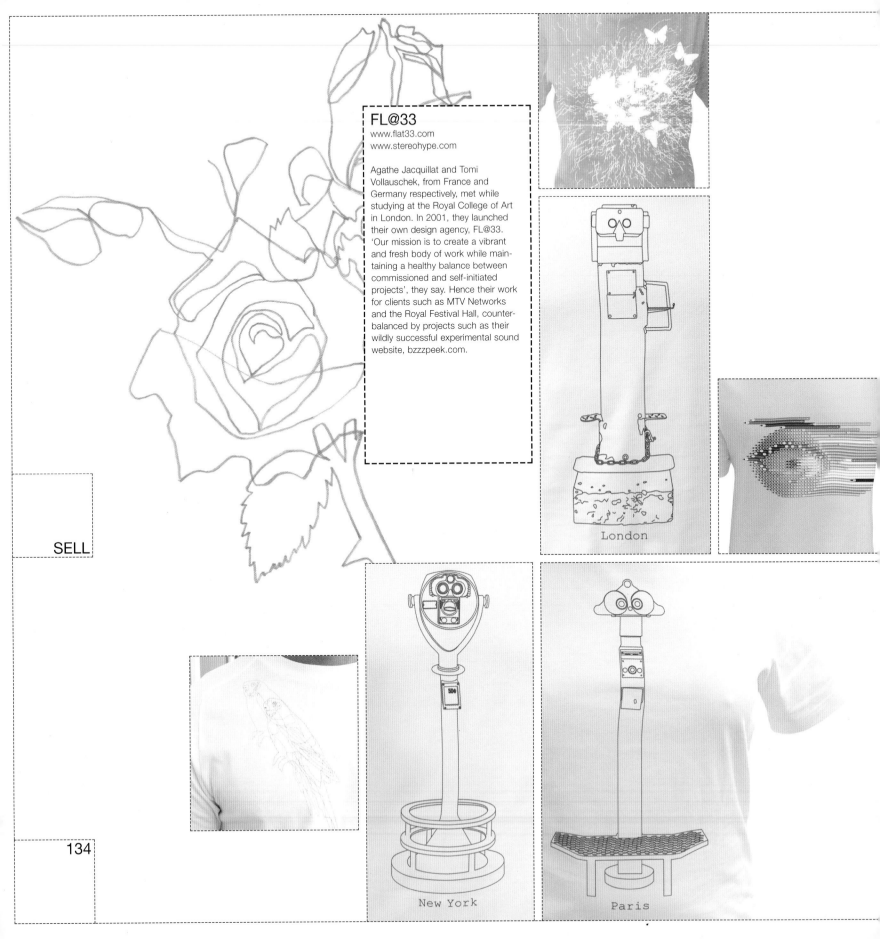

FL@33

www.flat33.com
www.stereohype.com

Agathe Jacquillat and Tomi
Vollauschek, from France and
Germany respectively, met while
studying at the Royal College of Art
in London. In 2001, they launched
their own design agency, FL@33.
'Our mission is to create a vibrant
and fresh body of work while main-
taining a healthy balance between
commissioned and self-initiated
projects', they say. Hence their work
for clients such as MTV Networks
and the Royal Festival Hall, counter-
balanced by projects such as their
wildly successful experimental sound
website, bzzzpeek.com.

SELL

London

New York

Paris

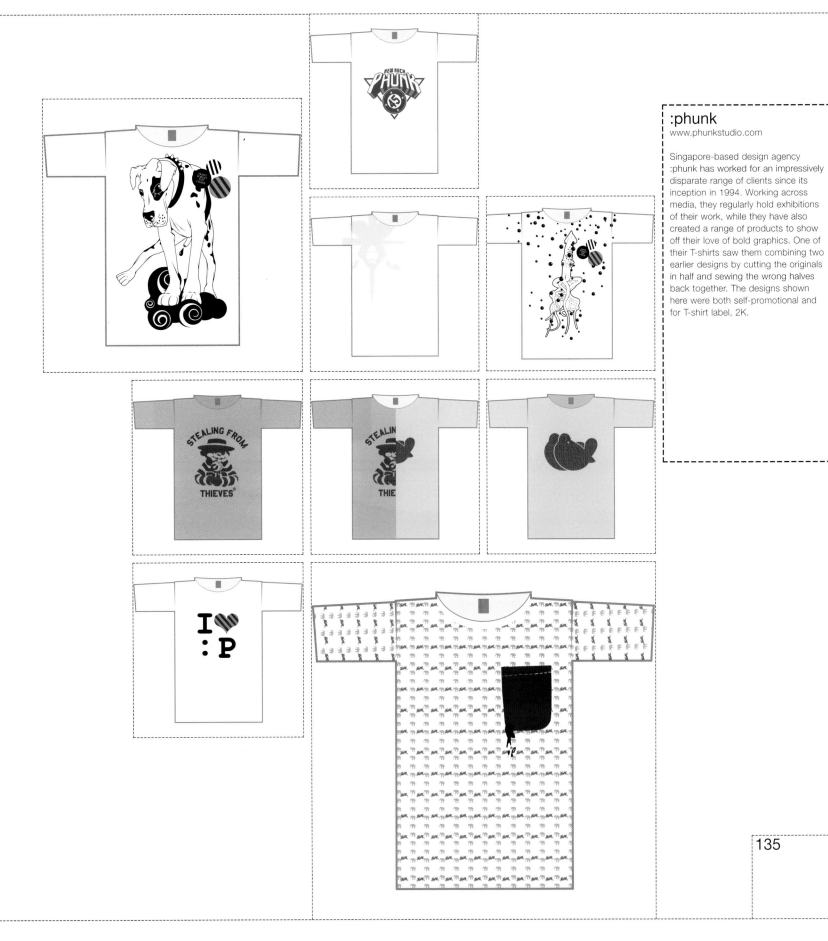

:phunk
www.phunkstudio.com

Singapore-based design agency
:phunk has worked for an impressively
disparate range of clients since its
inception in 1994. Working across
media, they regularly hold exhibitions
of their work, while they have also
created a range of products to show
off their love of bold graphics. One of
their T-shirts saw them combining two
earlier designs by cutting the originals
in half and sewing the wrong halves
back together. The designs shown
here were both self-promotional and
for T-shirt label, 2K.

Daniel Devlin
www.f-art.com

London-based artist Daniel Devlin
paints in a large shed at the end of
his garden and later produces T-shirts
which feature imagery taken from
these paintings. 'The designs take on
a bolder graphic quality when seen in
isolation on a T-shirt', he says proudly.

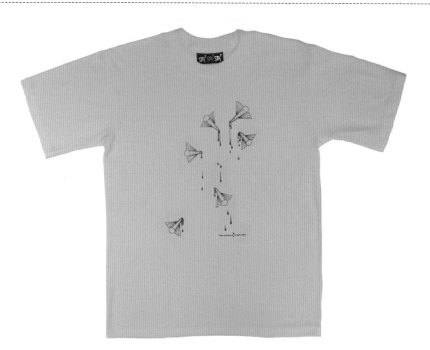

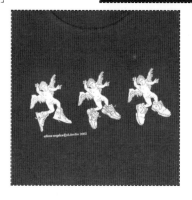

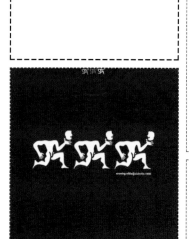

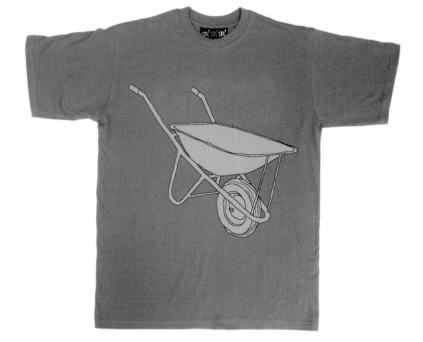

SELL

136

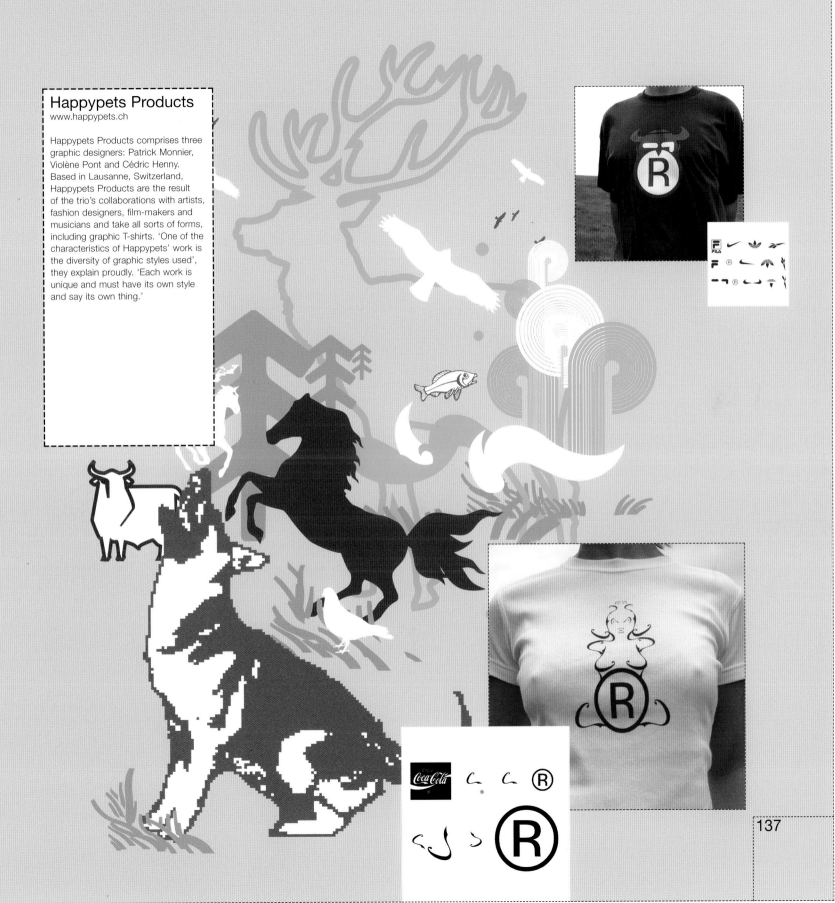

Happypets Products
www.happypets.ch

Happypets Products comprises three
graphic designers: Patrick Monnier,
Violène Pont and Cédric Henny.
Based in Lausanne, Switzerland,
Happypets Products are the result
of the trio's collaborations with artists,
fashion designers, film-makers and
musicians and take all sorts of forms,
including graphic T-shirts. 'One of the
characteristics of Happypets' work is
the diversity of graphic styles used',
they explain proudly. 'Each work is
unique and must have its own style
and say its own thing.'

137

Marie O'Connor

www.peepshow.org.uk

Illustrator, textile designer and fashion
consultant Marie O'Connor began
to print T-shirts as a way of showing
old work in a new way. 'After being
photocopied, the random pieces are
arranged economically onto an A3
silkscreen, making the most of the
space', she explains. 'It's all done
without preciousness, each illustration
slightly steps on another's toes. How
they are placed, by default, is the
print. Essentially the T-shirts become
back-issues of my drawings which
you can wear too.'
Design: Marie O'Connor.
Photography: Stephen Lenthall.

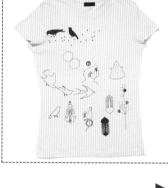

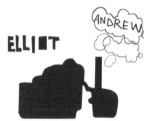

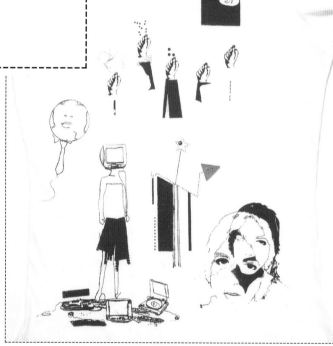

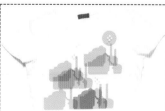

SELL

138

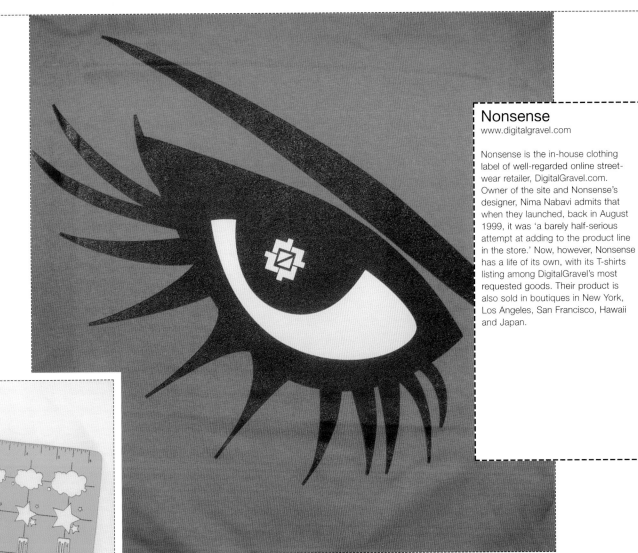

Nonsense
www.digitalgravel.com

Nonsense is the in-house clothing label of well-regarded online streetwear retailer, DigitalGravel.com. Owner of the site and Nonsense's designer, Nima Nabavi admits that when they launched, back in August 1999, it was 'a barely half-serious attempt at adding to the product line in the store.' Now, however, Nonsense has a life of its own, with its T-shirts listing among DigitalGravel's most requested goods. Their product is also sold in boutiques in New York, Los Angeles, San Francisco, Hawaii and Japan.

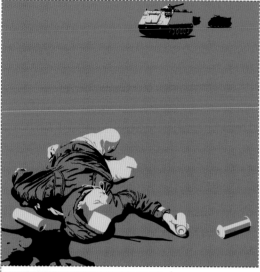

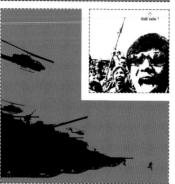

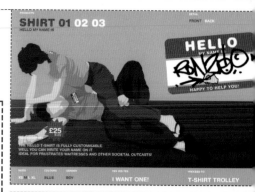

Less Rain
www.lessrain.co.uk

Perhaps better known for their interactive media work, London and Berlin design agency Less Rain produced a range of T-shirts to show that there's more to their company than technical know-how. 'Most of Less Rain's work takes life as concept-driven, tailor-made solutions for an interactive environment, be that online or offline', they explain. *Design: Carsten Schneider. Lars Eberle, Bas Koopmans.*

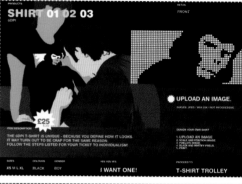

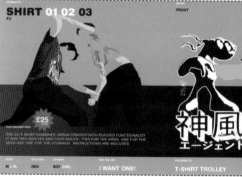

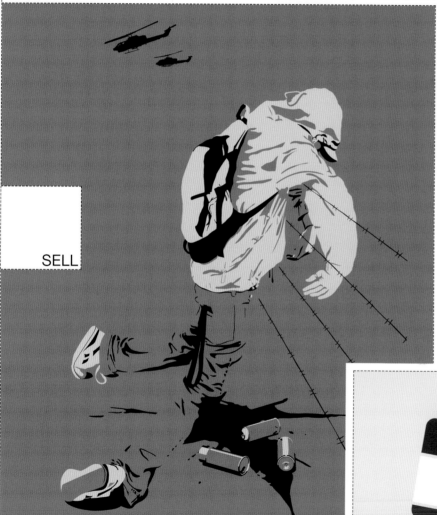

SELL

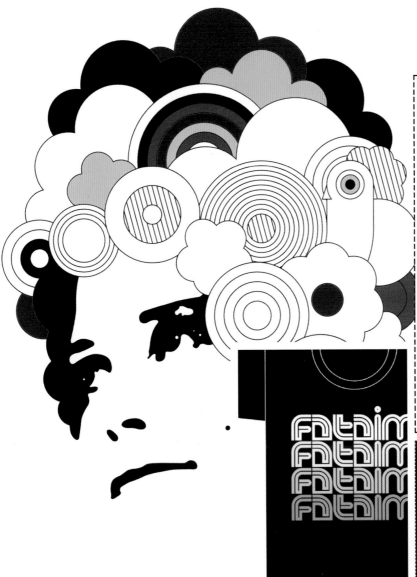

Rinzen

www.rinzen.com

'Rinzen take a post-ironic, post-pastoral, post-humourist approach to visual design', explains the Australian collective's co-founder Rilla Alexander (the other members are Steve Alexander, Adrian Clifford, Karl Maier and Craig Redman). 'We strive to be cheerful but not ironic, spontaneous but not haphazard, inclusive but not derivative.' Rightly famed for their year 2000 project, RMX//A Visual Remix Project, for which they remixed each others' work in a Chinese Whispers-style process, they have also printed T-shirts with their eye-catching graphics, and regularly work in print, web design and animation.

BEING BORING

BLACKPOOL ROCK & ROLL

Scott King
www.scottkingltd.com

Former art director of *i-D* and creative director of *Sleazenation* magazine, Scott King is also one-half of provocative art collective Crash!, on which he works with Matt Worley. His commercial clients include Diesel, Smirnoff and Island Records, while he designed this series of cheeky, slogan-based designs for Parlophone signing, Pet Shop Boys.

SELL

CLOSET HOMOSEXUAL

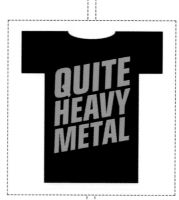

QUITE HEAVY METAL

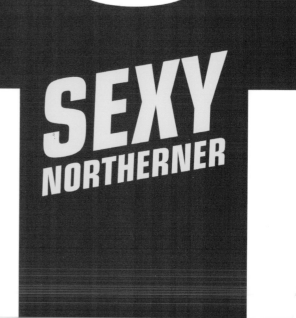

SEXY NORTHERNER